TADCASTER

THROUGH TIME

Paul Chrystal &
Mark Sunderland

AMBERLEY PUBLISHING

Acknowledgements

Thanks go to the following for their help and advice, and for being so generous with their photographs and postcards; the book would be much diminished without them. Any errors that remain are all mine.

Paul Bishop www.artofwar.org.uk for the illustration on p. 95; Peter Bradshaw, Tadcaster Community Archive; Anne Chrystal; Richard Hunt; Ian Glover for the photograph on p. 72; Geoff Mitchell, Headmaster, Tadcaster Grammar School; Gerry Nutton, Tadcaster Grammar School Old Students' Association; Ian Page; Sue Sheriff, St Mary's Church, Tadcaster; St Joseph's Pre-School, Tadcaster; David Skillen, Towton Battlefield Society; Paul Stebbings; Tadcaster Animal Supplies; Tadcaster Civic Society; Tadcaster Historical Society; Malcolm Ward, Ward's Butcher's; Diane Westmoreland; Keith Westmoreland.

Dedicated to Sydney Mottershead and Alan Sunderland for inspiring me to become a photographer – and for taking some of the old photographs!

Mark Sunderland

More of Mark Sunderland's work can be found at www.marksunderland.com
For more books on Yorkshire go to www.knaresboroughbookshop.com

First published 2010

Amberley Publishing Plc
Cirencester Road, Chalford,
Stroud, Gloucestershire, GL6 8PE

www.amberley-books.com

Copyright © Paul Chrystal & Mark Sunderland, 2010

The right of Paul Chrystal & Mark Sunderland to be identified as the Authors of this work has been asserted in accordance with the Copyrights, Designs and Patents Act 1988.

ISBN 978 1 4456 0203 5

British Library Cataloguing in Publication Data.
A catalogue record for this book is available from the British Library.

Typeset in 9.5pt on 12pt Celeste.
Typesetting by Amberley Publishing.
Printed in the UK.

Introduction

Richard Jackson got it about right in 1877 when he described Tadcaster as follows in his *Illustrated Guide to Yorkshire*:

> *Of all the landward towns in that great haughty shire,*
> *Old Tadcaster on Wharfe the highest may aspire;*
> *To her belongs a grace that ever will avail*
> *In her right honest meal, and, better still, her ale;*
> *For there the sovereign draft its power may never fear,*
> *As it can elsewhere find no rival, and no peer.*

Think of Tadcaster and you think of breweries and beer. The town has been brewing since 1341 but it really came into its own when domestic production was industrialised by the Smith family and others at the end of the nineteenth century leaving a legacy in the shape of Samuel Smith and John Smith, complemented today by a third, Molson Coors Brewing Company. Harry Speight, writing soon after Jackson, attests that beer was in the air: "*In our walks about Tadcaster certain odoriferous breezes make us conscious of the presence of these famous breweries... Tadcaster air is surcharged with the extract of malt.*"

The good brewing water from springs or popple-wells around the River Wharfe inspired the development of beer production here: add to that the importance of Tadcaster as a staging post on the London to Edinburgh road and, along with the three breweries, you begin to understand the plethora of inns and taverns in the town: it was vital that the town provided accommodation and refreshment for both man and horse. But it isn't all beer and skittles here, and spring water isn't the only natural resource that makes Tadcaster famous: Tadcaster magnesian limestone has long been a much sought after stone and many iconic English buildings, including York Minster no less, are built with it. The Romans knew all about this stone and called their settlement here *Calcaria*.

The Wharfe and its bridges are of course central to the town and account for its very existence and development. Around Tadcaster there are many fine buildings surviving from as far back as the fifteenth century: the oldest, the Ark has been serving the community for many years and still does today as local council offices; the striking viaduct, ever redundant as a means of crossing the Wharfe in a passenger train, now forms part of an enjoyable town walk, and from St Mary's church a beautiful William Morris window shines out.

The villages around Tadcaster are especially important for their military history. Towton was the site of England's biggest and bloodiest battle in the War of the Roses while six hundred years later Thorp Arch turned out pieces of ammunition by the million during the Second World War. More peacefully and cerebrally Boston Spa is now the home of the northern British Library and Bramham Park hosts the Bramham Horse Trials and Leeds Festival each year. The pub sign at The Wild Man in Streethouses was once very nearly a cause of embarrassment to Queen Victoria on her way to York.

All of this is covered in our book – in pictures old and new and in incisive, informative captions. It is, therefore, a brief, pictorial history of Tadcaster and the surrounding area which can be read straight through or dipped into page by page. Mark Sunderland, professional landscape photographer, grew up in Tadcaster and it is easy to see his affection for the place shining through in his imaginative and provocative contemporary photographs. He has done a fine job despite the problems sometimes caused by incessant traffic, rampant foliage, unattractive "street furniture", civic vandalism and demolition.

A book such as this is, of course, only as good as its photographs. For that reason it is important to acknowledge everyone who has lent their support; however, Peter Bradshaw deserves special mention as he has been particularly generous and supportive.

The style and ethos of the *Through Time* series precludes the use of footnotes and references; I would, nevertheless, like to acknowledge the following publications which have proved most useful and informative:

Anker, M. (ed), *Guided Tour and Short History of St Mary's Church* Tadcaster
Fiennes, C. *Through England on a Side Saddle in the Time of William and Mary*, The Leadenhall Press, 1888
Jackson, R. *Jackson's Illustrated Guide to Yorkshire* 1877
Nuttall, B. *A Walk Around Historical Tadcaster*, Tadcaster Civic Society 1996
 (ed) *Tadcaster Photo Album*, Tadcaster Civic Society 1986
 (ed) *Tadcaster Photo Album Volume II*, Tadcaster Civic Society 2002
 A Walk by the Wharfe at Tadcaster, Tadcaster Civic Society 1980
Page, I. *Tadcaster's Pubs – A Brief History*, Tadcaster Historical Society 2008
 (ed) *Tadcaster Photo Album Volume III*, Tadcaster Civic Society 2002
Tadcaster Historical Society, *Everyday Life in Tadcaster*, Tadcaster Historical Society 2005
 A Brief History of Tadcaster, Tadcaster Historical Society, 1998
Speight, H. *Two Thousand Years Of Tadcaster History*, Elliot Stock, London 1883
Swales, W. *The History of the Tower Brewery Tadcaster*, Bass Brewers, London 1991
Ward, D. *John Smith and His Tadcaster Brewery*, John Smith's North

Paul Chrystal 2010

Other titles by Paul Chrystal & Mark Sunderland in the *Through Time* series:
Knaresborough, Northallerton, North York Moors, Richmond, Villages Around York

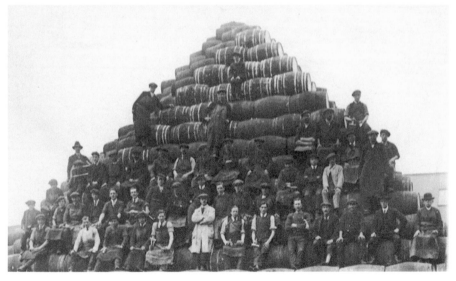

An impressive stack of barrels built by proud – and intrepid – John Smith coopers, 1925.

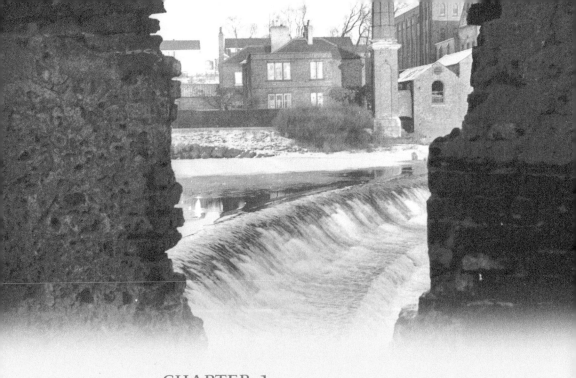

CHAPTER 1

The River Wharfe & Her Bridges

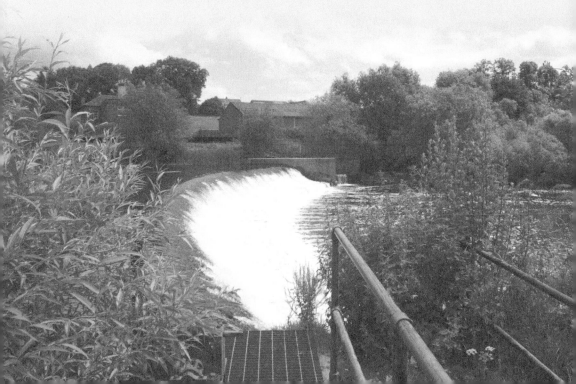

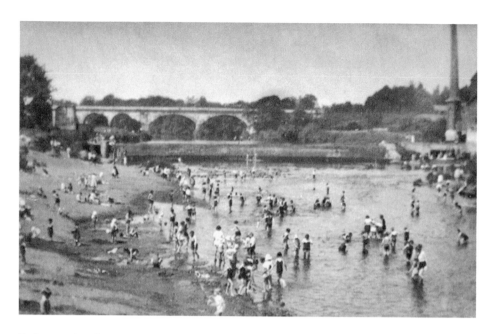

Tadcaster Beach 1933

A popular summer's day out not just for locals but for day-trippers from the towns of the West Riding looking for somewhere nearer and cheaper than Scarborough or Filey. The modern picture shows that the spot has still not lost its appeal. Tadcaster was founded by the Romans who called it *Calcaria* from the Latin word for *lime*, reflecting the limestone deposits that have been quarried there for centuries. Many famous buildings including York Minster are built from Tadcaster limestone, the stone being conveyed by boat to York (*per navem a Tadcastre usque Ebor*) according to the *Fabric Rolls* in the Minster); it was still going on in 1403: *"caryying unius shypfull petrarum per aquam."* 0/10 for the Latin.

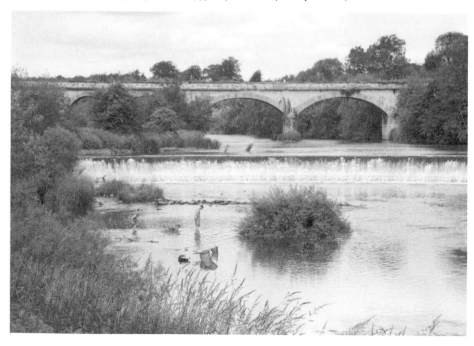

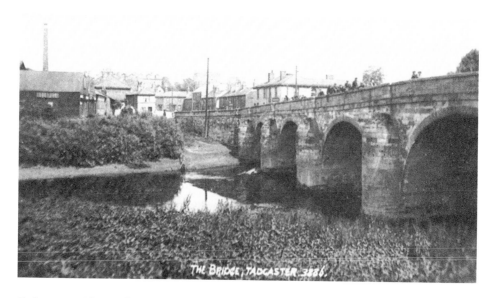

The Bridge, Tadcaster 3886.

Tadcaster Bridge and the Elephants' Watering Place

The original river crossing was a ford near the present site of St Mary's Church, followed by a wooden bridge. Around 1240, the first stone bridge was built nearby from stone quarried from the castle. We know that there has been a bridge here from the thirteenth century although the present bridge dates from around 1700 and was subsequently widened in the 1780 by John Carr. The bridge formed the boundary between the Ainsty and the West Riding until 1835 and it was here that royal visitors would be met and escorted on to the city of York. The Elephants' Watering Place is a little upstream and is the name given to an ancient right of way which passes through the river; it got its name from the elephants from visiting circuses which were watered there. The modern picture shows crowds on the bridge watching the end of the 2010 Duck Race – the third annual event organised by Tadcaster Community Swimming Pool.

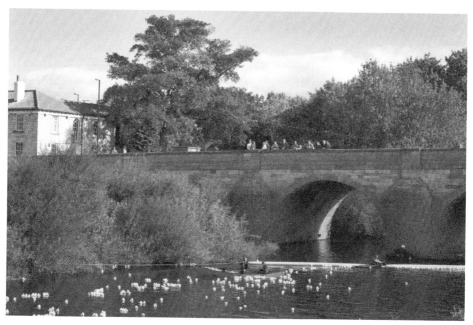

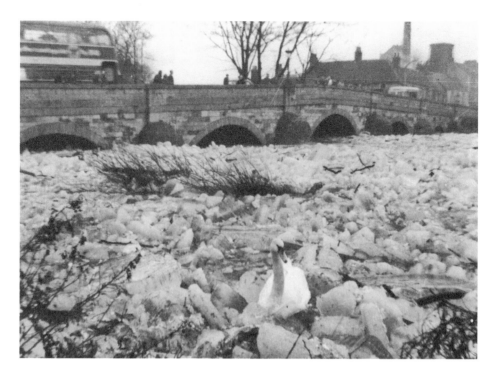

Tadcaster Bridge and a Marooned Swan

The bridge was described in 1540 by Leland, the King's surveyor as having *"8 faire arches of stone. Sum say there that it was laste made of part of the ruines of the old castelle."* Tadcaster was the Parliamentary headquarters during the Civil War in 1942. At 11am on Tuesday 7 December 1642 the Battle of Tadcaster took place around Tadcaster Bridge between the Parliamentarian Sir Thomas Fairfax's 900 men and the Earl of Newcastle's 8,000 strong Royalist army. The Royalists took the town.

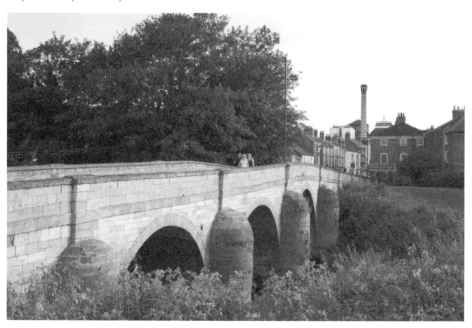

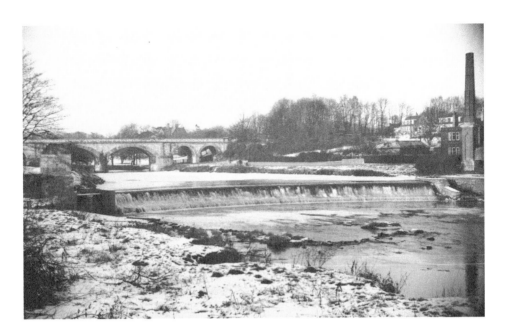

Hudson's Folly and The Weir

A quarter of a mile above the Wharfe bridge an imposing viaduct of eleven arches spans the River Wharfe. This was built as part of the projected Leeds to York railway promoted by the industrialist George Hudson, Railway King, for the North Midland Railway. The go-ahead for the line was given in 1846: it was to run from Copmanthorpe to Cross Gates, meeting the Church Fenton to Harrogate line between Tadcaster and Stutton. Unfortunately, Hudson's financial problems in 1849 and the marshy land under the tracks meant that the line was never completed and the viaduct was only ever used by trains taking coal to Ingleby Mills from 1882-1955. The need for the line evaporated completely with the opening of the Micklethorpe to Church Fenton line in 1869. A Grade II listed building it is now the integral feature of the Viaduct Walk which starts at the Wetherby Road. It was bought by the town council from British Rail for £100 in 1980.

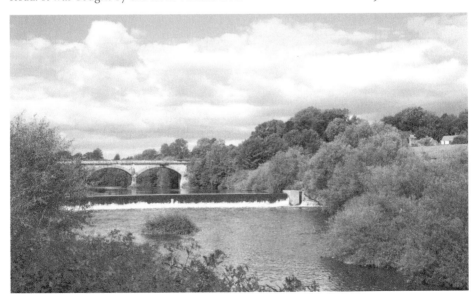

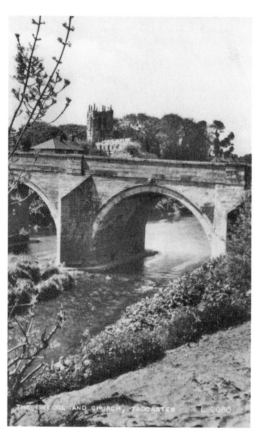

Bridge and Church

Tadcaster features in the *Anglo-Saxon Chronicle* as where King Harold assembled his army and fleet before entering York and then proceeding to the Battle of Stamford Bridge in 1066. Bede describes it as *Kaelcacestir, civitatem Calcariam.* The name *Tata* comes into play sometime in between Bede and *Domesday.* The Doomsday entry for Tadcaster is as follows: *Two Manors. In Tatecastre, Dunstan and Turchil had eight carucates of land for geld, where four ploughs may be. Now, William de Parci has three ploughs and 19 villanes and 11 bordars having four ploughs, and two mills of ten shillings (annual value). Sixteen acres of meadow are there. The whole manors, five quaranteens in length, and five in breadth. In King Edward's time they were worth forty shillings; now one hundred shillings.*

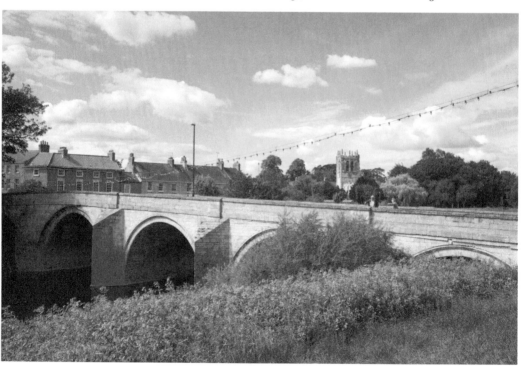

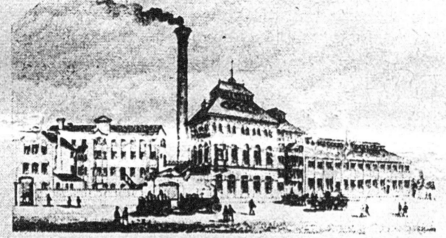

MAHO ALE.

JOHN SMITH'S

TADCASTER BREWERY CO., Ltd.

THE BREWERY

CHAPTER 2

Tadcaster Breweries
& Public Houses

JOHN SMITH, TADCASTER BREWERY.

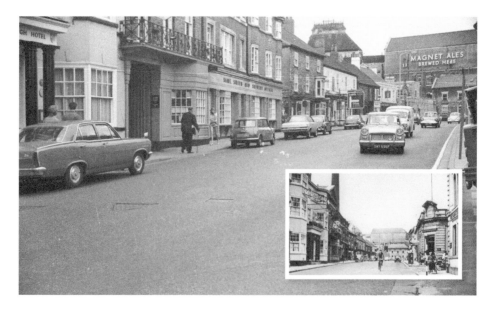

Sam Smith's Old Brewery Offices

The Old Brewery at Tadcaster on the left here was established in 1758 (see p.18); it is the smallest of the three Tadcaster breweries, independent and the oldest brewery in Yorkshire. The original well was sunk in 1758 and is still used today; the water for the beers is drawn from 85 feet underground. Samuel Smith still ferments ale and stout in traditional Yorkshire stone 'squares' – roofed fermenting vessels made of solid blocks of slate. The strain of yeast used today has been used at the Old Brewery continuously since the beginning of the twentieth century, one of the oldest unchanged strains in the country. The brewery cooper makes and repairs all the wooden casks used for the brewery's 'Old Brewery Bitter'. The inset shows the brewery business in its previous guise as the Londesborough Hotel – see p.27.

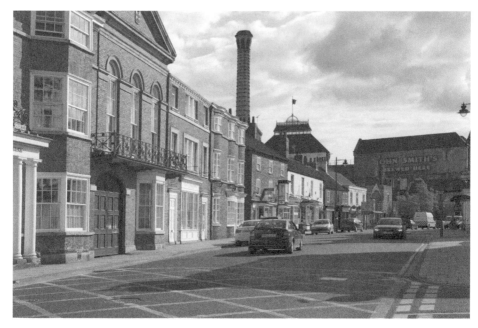

Shire Horse Delivery

Magnificent grey shire horses weighing more than a ton each are stabled at the Old Brewery and still deliver to some local pubs. The first evidence of brewing in Tadcaster is in early tax lists which indicate the presence of brewhouses in 1341. In about 1400 good ale sold for 1½ d per gallon; by 1500 the price had doubled. In the seventeenth century most of the brewhouses recorded were supplying large houses, inns or posthouses. The 1378 Poll Tax returns show the population of Tadcaster then to be 400 including two brewers, 5 innkeepers, 3 merchants, 1 draper, 4 wrights or blacksmiths, a dyer, tailor, mason, 2 shoemakers. The rest were employed in agriculture.

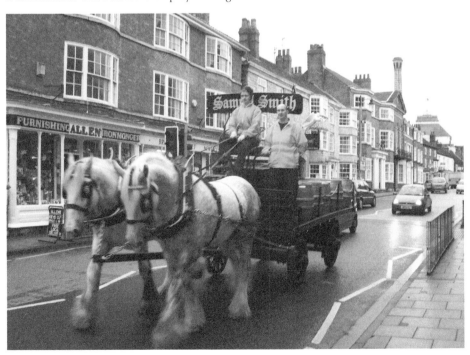

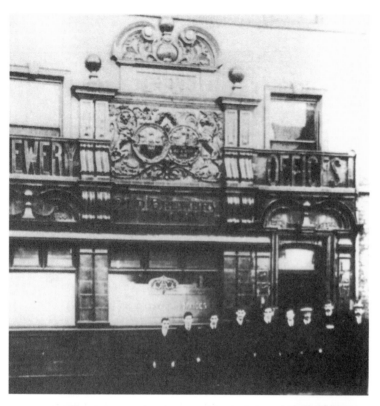

Sam Smith Staff
Office staff outside the building in High Street in the 1900s. The beer that is made from the hard magnesium limestone water, rich in sulphate of lime, from Tadcaster's wells, was bright bitter beer which was taking over from porters – the traditional working-man's drink. You can still see the springs which provided these hard waters on the beach behind the church. Known locally as popple-wells they were important not just in brewing but for the provision of 'popple-water' on the tables of Tadcaster's coaching inns: an early form of mineral water.

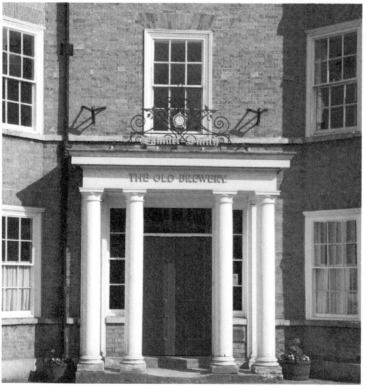

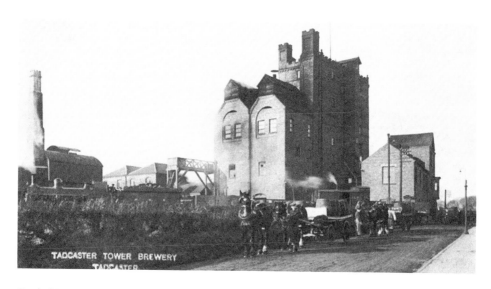

TADCASTER TOWER BREWERY
TADCASTER

Snobs' Brewery

Built on land for £484 bought from George Hudson's ill-fated North East Railway Company in 1882 at the end of Wetherby Road bound by the Harrogate line and the branch line to the viaduct. Tower brewery earned its nickname from the aloofness of the original owners: affluent young men from fashionable York who rarely came to Tadcaster and remained somewhat mysterious to local townsfolk and even the workers. The owners were in fact Hotham & Co – brewers of York in George Street since 1716 who also owned 90 of the 284 pubs in the city around 1870. In 1875 Hotham's sold up for £36,000 to a consortium of York and London businessmen who promptly bought Yates's brewery in York for £12,000 including a further 12 York pubs. The new owners were in their late twenties, Old Etonians and shared a passion for horse racing which they were able to indulge at the Knavesmire. The company changed its name to The Tadcaster Tower Brewery Company in November 1882. The old picture shows brewery drays setting off for a delivery and North Eastern steam engines in the yard on the lines which served the brewery.

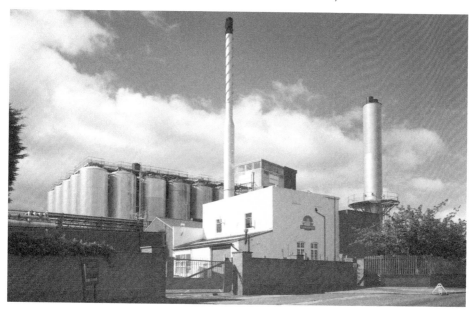

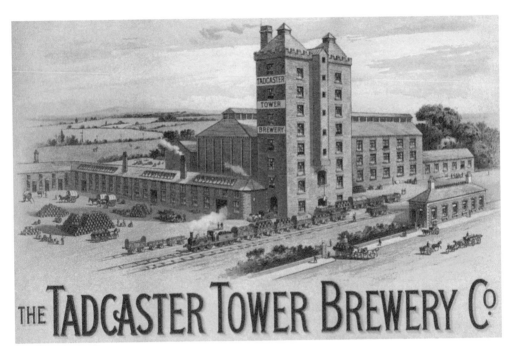

THE TADCASTER TOWER BREWERY Co.

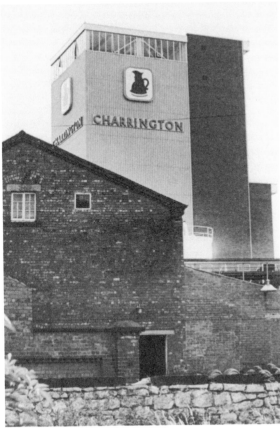

Tower Brewery

The decision to relocate to Tadcaster had been largely based on the superiority of the water here, the town's importance as a staging post for goods traffic and the fact that it was a railway town; no doubt, the reputation of Samuel Smith's and John Smith's also had something to do with the decision. Tower Ales were supplied as far afield as London and the company became agents for porter from Watney, Combe and Reid. Tower also became a key supplier to the army at Strensall Camp north of York. In 1885 the brewery employed 19 men at Tadcaster including two coopers from Burton's (malting and bottling remained in George Street, York). The weekly wages bill was £21 5s 4d. In 1884 Tower bought Mitchell's Whitwood Mere brewery, Castleford, and nine pubs and, in 1888, the twelve pubs and brewery of Edward Smith, Grimsby. Production at Tadcaster in 1893 was 74,660 barrrels; the company owned 280 pubs and off licenses. The newer picture shows the brewery in its Charrington days.

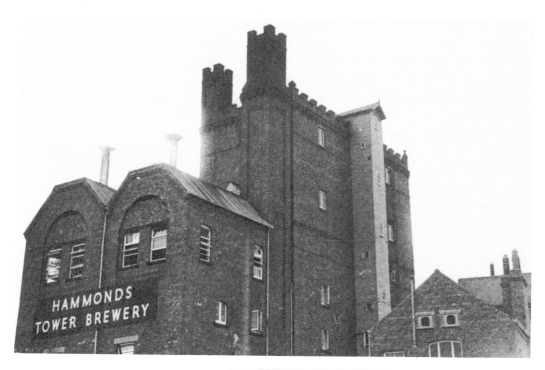

Tower Brewery: Hammonds – Charringtons – Bass – Coors
Ronald Castle's brewery in Chapmangate, Pocklington was bought in 1921 along with 10 pubs, but the main event that year was the launch of a new bottled beer, originally called Pale Ale but changed to Prize Medal – an auspicious choice in view of the medals it won over the years. Resistance to this bottled beer amongst drinkers ran high – how could beer in a bottle taste as good as a beer from a cask? – and from the Tower brewery coopers. In 1926 total output for all beers including bottled beers was 54,000 barrels. Tower Brewery was taken over by the large 700 pub Bradford brewery Hammonds in 1946, then Charringtons in 1962 and then the Bass group in 1967. Today it is part of of Molson Coors Brewers Ltd formed in 2002 by the merger of the Coors Brewing Company in the USA and most of the former Bass Brewers in the UK.

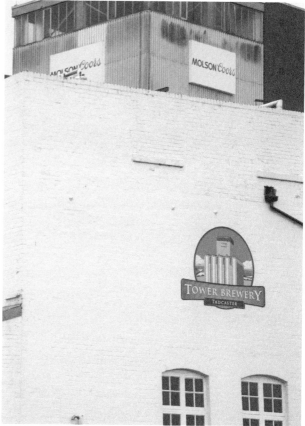

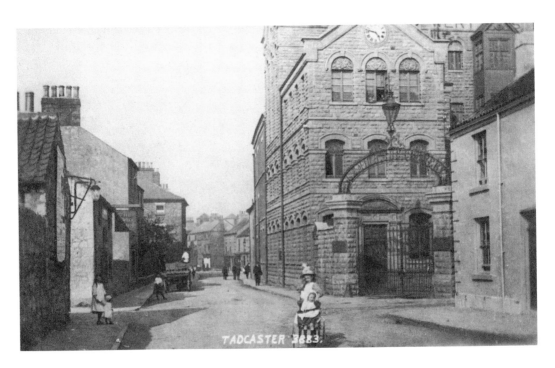

John Smith

John Smith was the son of a tanner from Meanwood in Leeds; he acquired the ramshackle Backhouse & Hartley Tadcaster brewery in 1847. When Lord Londesborough's estate was sold off in 1873 John Smith bought a large portion of land along Centre Lane and built a new brewery. John died in 1879 and did not see his £130,000 building which opened in 1883. His brothers William and Samuel inherited the business and by 1890 they were producing 3000 barrels a week; Samuel's son Samuel Jnr then proceeded to re-equip the Old Brewery, re-open it in his own name in 1886 in competition with the established firm of John Smith's. The two photographs show how little this iconic view has changed over the years.

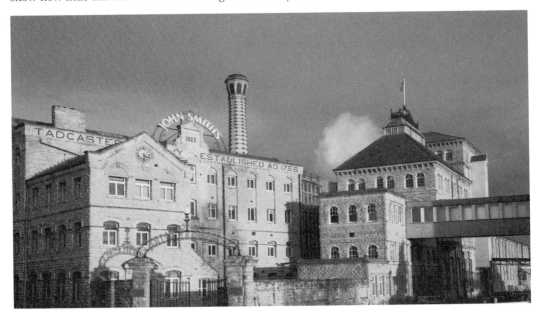

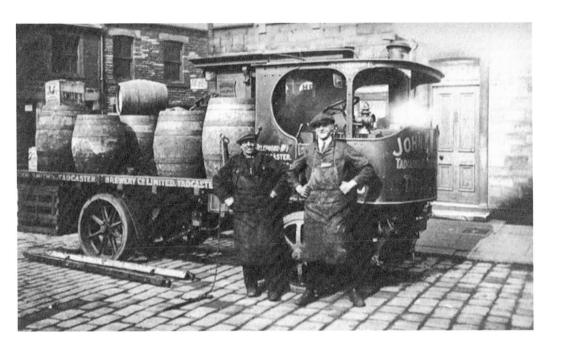

John Smith Steaming

A steaming John Smith's steam wagon delivering – Arthur Waters was the driver and his drayman was Bill Parker. Tadcaster had other breweries in the early days: in the 1870s Benjamin Braime started a small brewery (The Victoria Brewery) next to the new John Smith brewery; another business, Wilson and Cundall opened up in Maltkin Square, the site of the current central car park. It ceased trading after 1893 and its premises were taken over by Benjamin Braime who then sold the High Street brewery to John Smith's. Braime's Brewery continued in Maltkin Square until 1906 when it too went bankrupt. Braime's brewery in Malt Kiln Square was another early Tadcaster brewery formed in 1895 by the amalgamation of Wilson & Cundall's New Brewery and Braime's Victoria Brewery. The new picture shows a Fosters tanker entering the site from the A162.

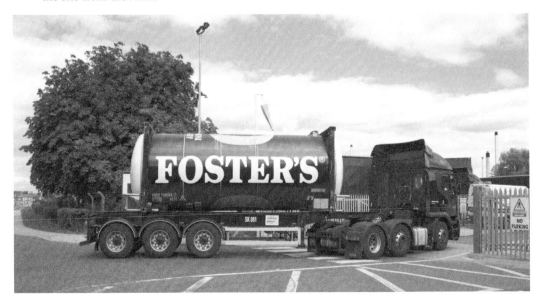

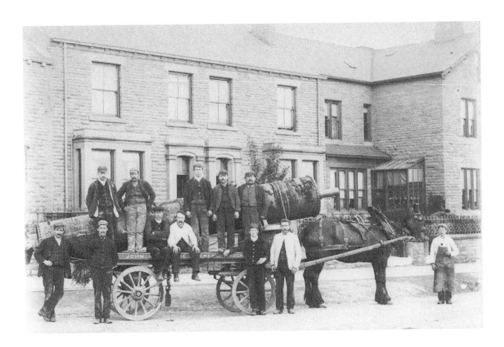

Delivering Parts to John Smith's

Delivery of some crucial equipment to the brewery and pausing for a photograph. The magnet trademark was registered in September 1908 in Brussels and symbolises strength. The description on the certificate (# 43449) reads: *"cette marqueé represente un aimant surmonté du mot – Magnet"*. Wills in the 1720s indicate that brewing could be very lucrative: Thomas Morris left 85 gallons of beer, 4 hogsheads and 60 barrels with accounts as far away as The White Swan in York. Thomas Beaumont left 80 quarters of malt and lots of equipment – a business which ultimately led to the establishment of John Smith's.

The Royal Oak

In Wighill Lane and apparently named after HMS *Royal Oak*, the pub, still open, has been in existence since before 1822. In 1379 there were five 'hostilers' out of a population of 400; in 1837 there were 24 inns and 11 beer houses – one pub for every 70 inhabitants when the population was about 2,400. Take out the women and children and it's nearer one in 20! The older picture shows a float in one of the Pram Races of the 1970s

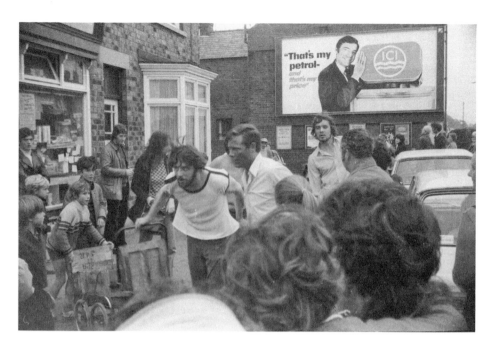

The Leeds Arms Pram Race

A group of contestants for a 1970s pram race; the neighbouring house and shop remain the same and the advertising hoarding is still there. In 1697 Celia Fiennes (the daughter of a Civil War Roundhead colonel) who rode side-saddle through the whole of England and much of Scotland with only two servants for company described Tadcaster thus: *"a very good little town for travelers, mostly inns and little tradesmen's houses."* Defoe, touring around the same time, only briefly mentions Tadcaster's bridge and its lack of antiquity. In 1686 we know that Tadcaster could provide fifty beds and stabling for seventy-two horses in any one night.

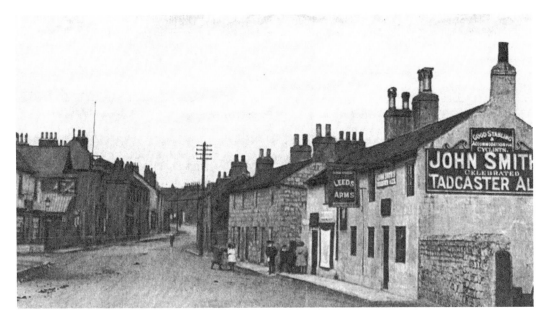

The Leeds Arms

Owned by the Earl of Egremont who sold it to York brewers Bulmers in 1828 when it was called The Angel; the sale included a cow house, pigsties, coalhouse and stables. It was renamed the Drovers Arms in 1844 to reflect its position on a road frequented by drovers and acquired in 1875 by Hotham & Co who went on to establish Tower Brewery; it was then bought by John Smith's in 1885. In 1880 it had become the Leeds Arms, was demolished in 1933 and replaced with the present building. The older picture shows how the pub promoted its good stabling while at the same time attracted cyclists.

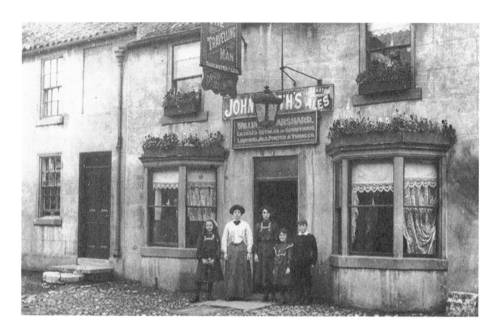

The Travelling Man

Opposite The Leeds Arms it opened in about 1855 and was bought in 1896 by John Smith's. It was demolished around 1975 and replaced with modern housing; its licence wasn't renewed in 1968 although Tadcaster Justices did agree to grant a licence for a new pub in its place in Stutton Road – The Jackdaw. In 1797 the occupant Hannah Whitehead was officially described as such: *"Remark – this tenant is very old and industrious and the rent* [4s per annum] *must remain for her life as present – she built it and the income arising from the underletting them supports her."*

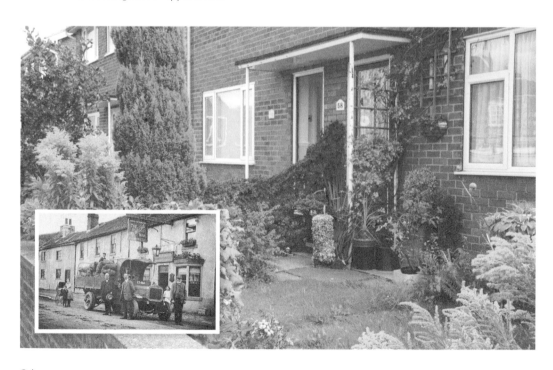

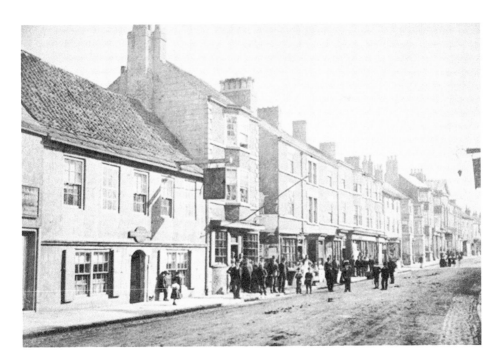

The Golden Lion

A late nineteenth century photograph of Bridge Street showing the Golden Lion Inn. The name and sign – the Flanders Lion – reflect the origins of English brewing as it was Flemish brewers who introduced the hop to England. The three-storey buildings to the right are still there today. Many of the pubs like the Golden Lion were coaching inns; fifty coaches per day passed through the town during the heydays of coaching. The Golden Lion specialised in heavy baggage wagons known as slow coaches. The pristine building it has now become looks somewhat less used than the pub was.

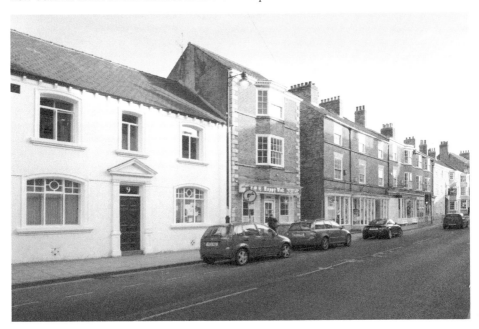

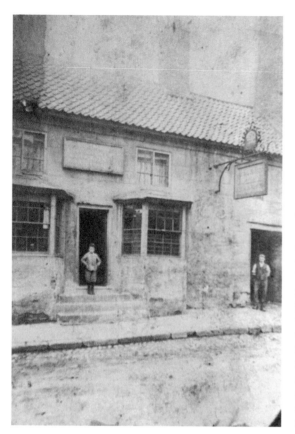

The George & Dragon

Originally at 18 High Street it was first called The Black Swan and then The George – all before 1830. It was owned by the Chantry chapel of St Nicholas' in St Mary's church around 1548 and featured a 1592 stained glass in the window which pictured a Tudor Rose with the initials W. K. – the sign of the George who belonged to the Chantry of St Nicholas. The square archway to the right was knocked down in the 1900s after a drayman was decapitated while delivering in his horse and cart. It is now Tykes Tea Rooms.

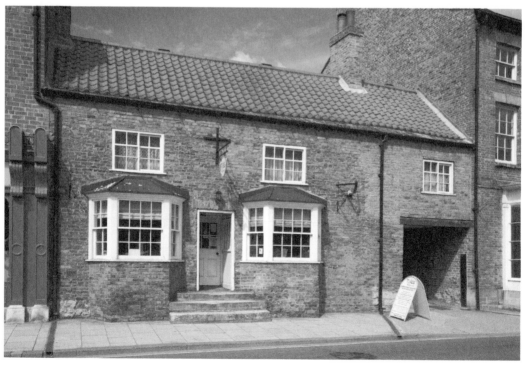

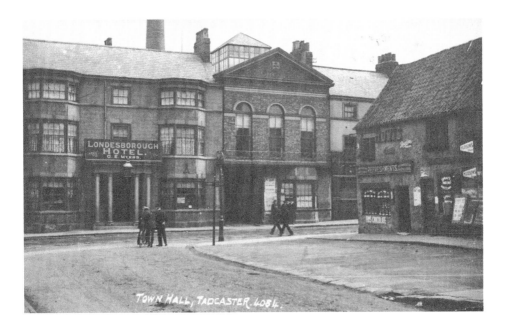

TOWN HALL, TADCASTER. 4084.

The Londesborough Hotel

The Londesborough Hotel, family, commercial and posting house, was reopened in 1855 on the site of the old coaching inn, The White Horse. From 1875-1877 it deputised as the parish church while St Mary's was being rebuilt. The Londesborough closed in 1976 to become the offices for Samuel Smith's brewery. To the right is the Town Hall built by Lord Londesborough bearing his insignia. Election results were announced from the balconies. It was converted into Tadcaster's first cinema – The Cosy Cinema – and lasted until the Regal opened in late 1930s. The café and confectioners on the corner of Market Place was run by a C. Woodson and later by a Miss Couch; the building was demolished in 1930 and the Midland Bank bought the site. Miss Couch moved in to the High Street. The Market Place was the venue for a great number of entertainments – not least the Friday evening performance of a man who lay on a bed of broken glass. The inset advertises a couple of splendid films showing at the Cosy.

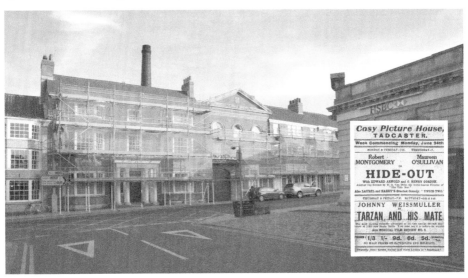

The Angel Commercial Inn

Known in Tudor days as the Red Hart it still retains some of its Tudor architecture in the doorway; the Angel closed in 1855 to make way for the Londesborough Arms. Next door was The White Horse, a coaching inn hit hard by the arrival of the railways and closing temporarily in 1840. However, Lord Londesborough needed somewhere to put up his guests on race days and so those whom he could not accommodate at Grimston Hall were, after 1855 when he reopened it and renamed it The Londesborough Hotel, offered rooms here. Matthew Kidd was landlord of the Angel when it was sold to Lord Londesborough; part of the deal was that Kidd became landlord of the Londesborough. It finally closed in 1976 to become the offices of Sam Smith's brewery. The new photograph is the Angel and White Horse pub, to the left of the offices.

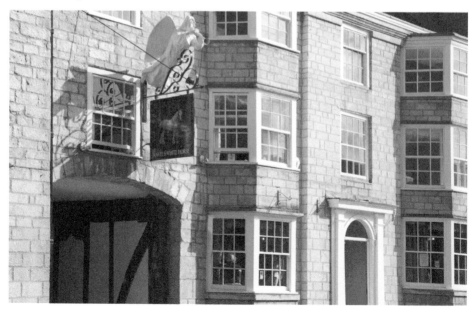

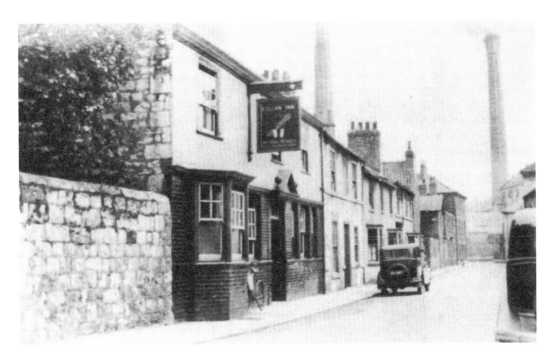

The Falcon

This June 1935 photograph shows the Falcon Inn; the tiles under the windows (now gone) were green, a common feature on John Smith pubs. The house to the right was later converted into an extension for the pub. The buildings further on down the road were demolished to make way for a car park. One of the shops was a sweet shop run by a Mrs Noble; before that in the 1920s it was a grocer run by "Stut" Jennings, so called because of his speech impediment.

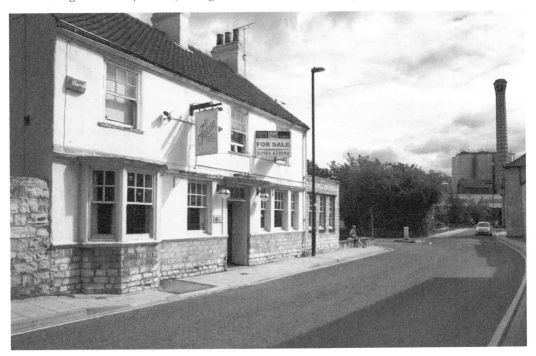

The Robin Hood
Run by Jane Midlam in 1822 Stoker's
Brewery of Towton supplied it at one time;
it was in the hands of Anna Webber in the
early twentieth century (possibly the lady
in the photograph) and then operated by
Bertie Mapplebeck in 1936.

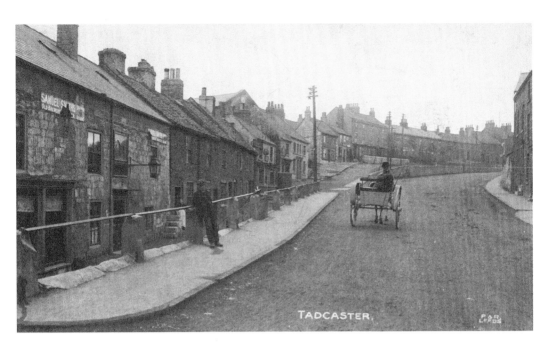

The Bay Horse

Originally known as the Smith's Arms in the eighteenth century, early nineteenth century records show the pub to have included a smith and was owned by John Houseman, a blacksmith. It remained in the family until 1844 when it was sold with barn, stable, garth and orchard. John Smith, the brewer, bought it in 1858 and then sold it onto Lord Londesborough in 1867. It reverted to John Smith in 1873 and, as the modern picture shows, is still open.

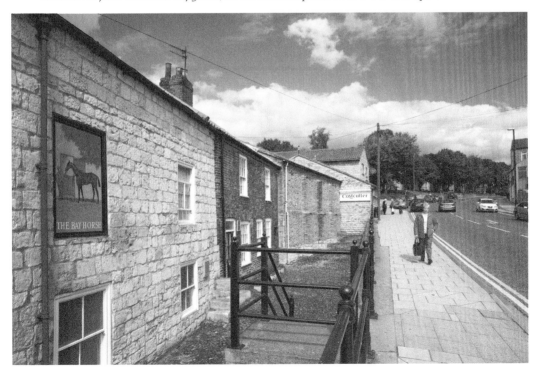

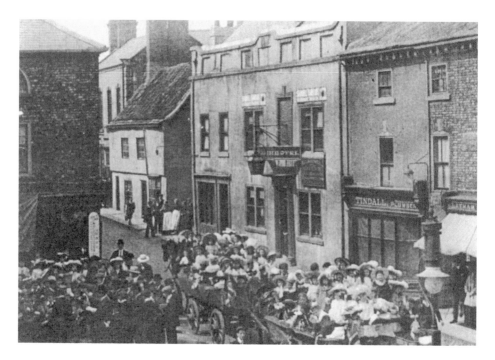

The Railway Hotel

The Bull and Dog coaching inn changed its name to The Railway Hotel in 1837 when it was acquired by the Wharfedale Brewery of Wetherby from the 6th Duke of Devonshire. In 1856 the then landlord Godfrey Braim was the victim of an early rail accident: he died in a collision at Church Fenton while returning from the Market Weighton Agricultural Show. Full details can be found on his tombstone in St Mary's. Braim's successor, William Proud, eyeing the rise of the railways, established a shuttle coach service to Bolton Percy station *"to meet every train during the day."* The new photograph shows the major changes made to Market Place since the earlier photograph was taken.

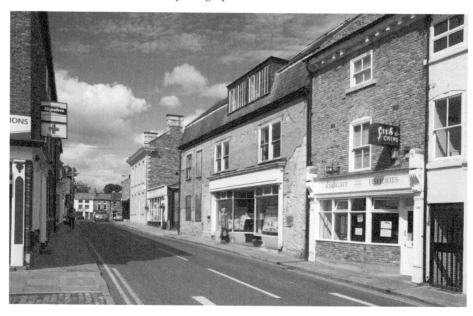

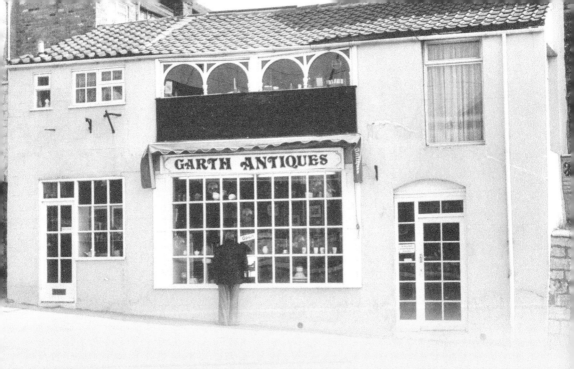

CHAPTER 3
Tadcaster Shops, Industry & Business

Kettlewell's Yard, Westgate 1962

Kettlewell's, building contractors, was taken over by F. R. Evans of Leeds and later closed with work moving to Leeds. The old picture shows Alan Sunderland outside the joiner's shop talking to his wife Barbara. Building of a very different kind was taking place in the eleventh century: William de Percy built the motte and bailey for Tadcaster Castle using stone salvaged from Roman ruins. Having been abandoned in the early twelfth century it was briefly re-occupied and re-fortified with cannon during the Civil War; all that remains is the castle motte. The outline of the long demolished southern bailey has since influenced the layout of the surrounding streets. The building to the right in the modern shot is the back of the restored Old Vicarage (p. 64), now visible through the gate on Westgate since the demolition of the workshops and the Regal Cinema.

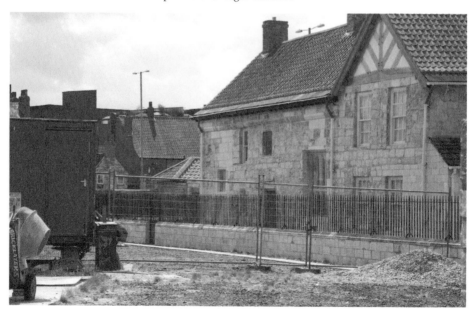

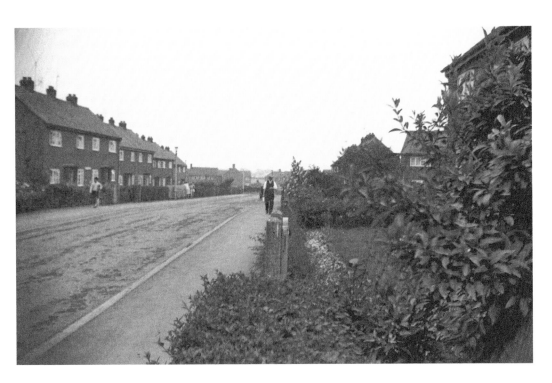

Coming Home with the Milk

This gentleman is returning to Auster Bank View from Ken Yeadon's shop on Auster Bank Crescent with an extra pint of milk. Ken's, or simply "The Shop" to Auster Bank residents, was a busy local grocer's where bread orders could be collected on a Saturday morning. Sadly the shop is no more, replaced by a house, so residents face a longer walk for extra milk and bread these days.

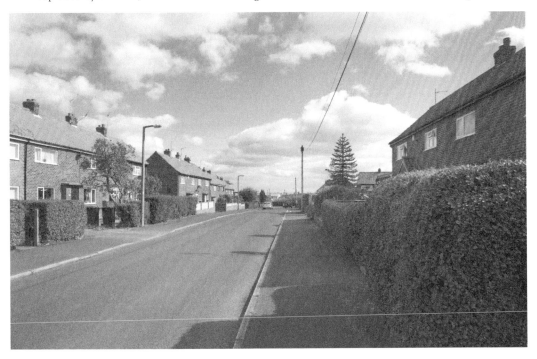

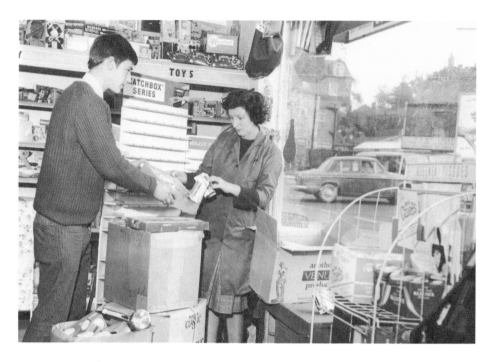

Unexploded Bomb at the Paper Shop

The discovery of a box of degrading gelignite whilst demolishing cottages on Rosemary Row caused a major evacuation of the centre of Tadcaster as far as Grange Estate up the hill and Sam Smith's over the river. A bomb disposal squad carried out a controlled explosion. During the evacuation sixteen crates of beer disappeared from an unattended Sam Smith's lorry! Westmoreland's Newsagents was owned by Geoff and Ella Westmoreland and Ella is seen here assisted by son Keith clearing the shop window "just in case". The shop continued as a newsagent for some years and is now Tadcaster Animal Supplies.

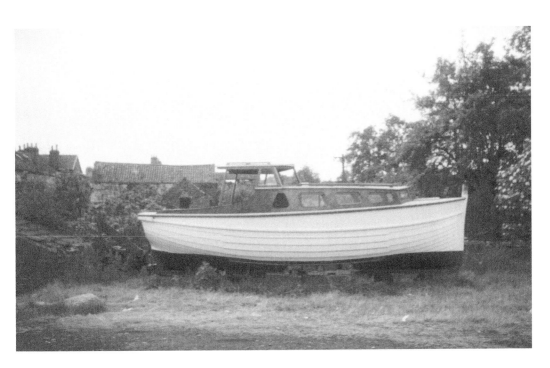

Sunrise behind Wards Butcher's 1965

Eddie Ward had a couple of boats which plied the Ouse. The one in the photograph was *Sunrise* which was moored at Bishopthorpe and frequently used by Tadcaster boys, including Mark Sunderland who took the modern photograph here, to fish from. The site is still the empty parking area behind Ward's and the Leeds Arms. The houses on Parkland Drive built in the '80s can be seen in the background.

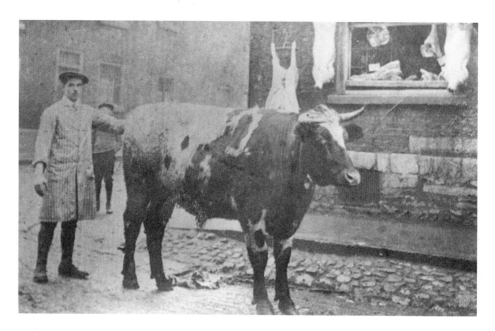

Death Row about 1918

This bull is soon to meet its end at Hilltop butcher's in aptly named Oxton Lane. The picture shows Harry Shilleto who was born in Tadcaster in the 1880s; he opened the butcher's in 1914 and went on to run Golf Links farm; he died age ninety-four. The photograph is from 1918. Part of the butcher's is in the background. It was originally The Rose and Crown public house, a former coaching inn, which became a private residence after 1850. It was demolished in the 1970s to make way for the Hillside housing estate.

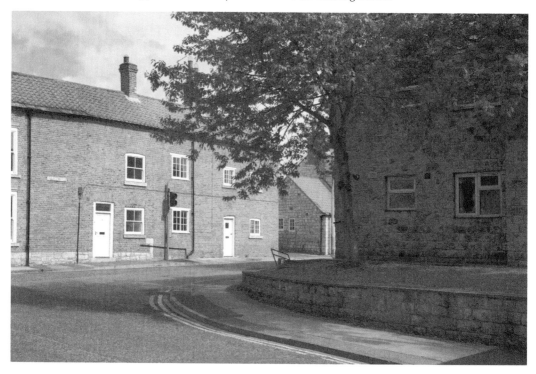

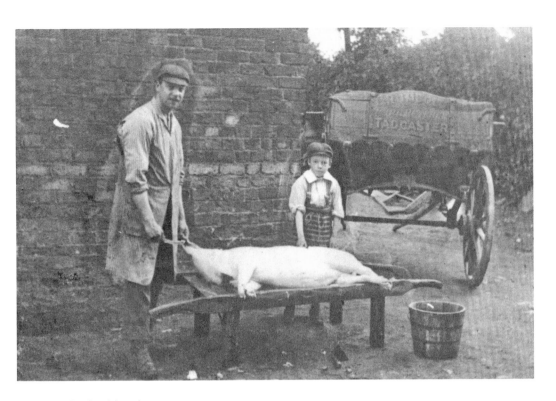

Butcher's Old and New
The older photograph captures a butcher (Crumbold's?) at work on a pig in the 1930s. Note the blood bucket. Malcolm Ward in the modern shot shows how things have moved on in the butchery business. But not for the pig...

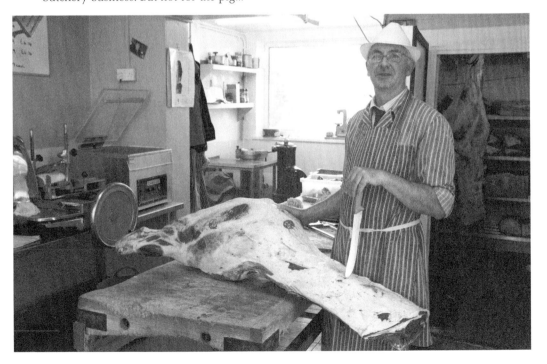

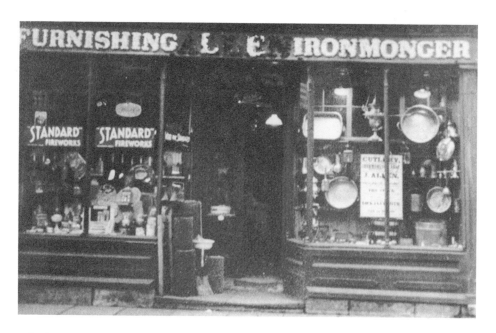

Allen's Ironmonger's

The ironmonger's run by John Allen in Bridge Street opened in 1851 and stayed in the family until the 1980s. Tin baths, oil paints, lawn mowers, tyres and, as the sign here shows, fireworks were all for sale. The shop continues to this day as the modern picture shows.

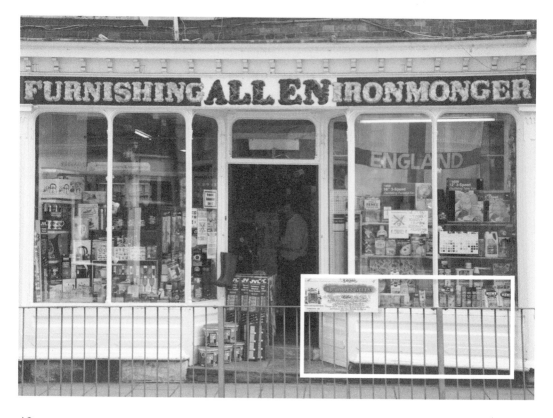

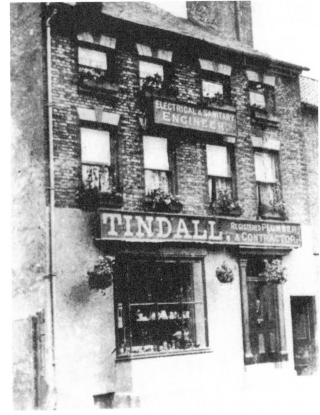

Tindall's Plumbers *c.* 1913
Plumbers, electrical and sanitary
engineers at 16 High Street
George Tindall, born 1859,
was one of the workers on the
rebuilding of St Mary's church.
Tindall's was originally in
Market Place. Note the hanging
baskets. A contemporary
advertisement describes Mr
Tindall as a bell hanger too but
his specialisation was of course
*"every description of sanitation...
residences, public buildings,
greenhouses &c...work carried
out by efficient workmen only."*

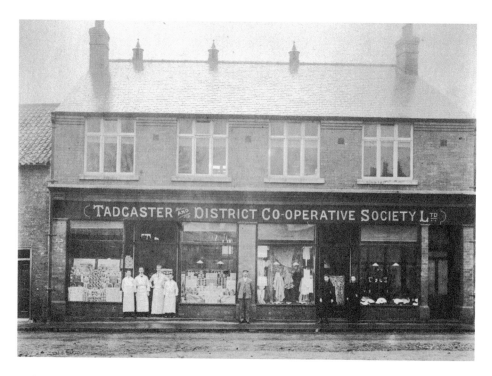

Tadcaster and District Co-operative Society

The Tadcaster Co-op pre 1910 before the bakery and butchery departments moved into two houses to the left of the shop. This picture shows three proud members of staff from the grocery department. Pelaw polishes seem to have a monopoly on the window advertising even over the Ideal evaporated milk and women's fashion displays. The Co-op closed in 1984 and the building was demolished in 1986. Today the building hosts society of a different kind in the form of Tadcaster Social Club.

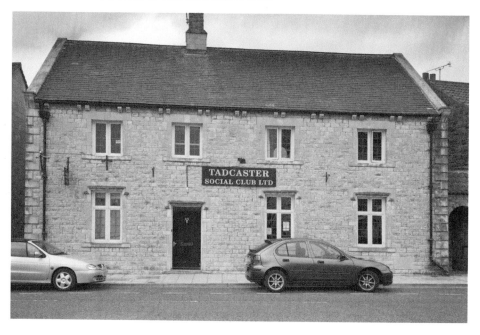

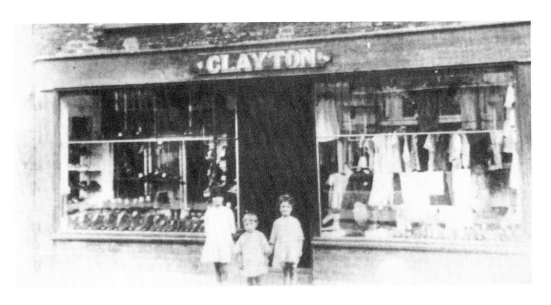

Clayton's
Lily, Rose and Violet Clayton outside George Clayton's gentleman's and ladies' outfitters in 1923. The shop was at 20 Kirkgate and was bought by Clayton in the early 1900s, remaining in the Clayton family until the 1980s. Before he bought this business George Clayton was a dealer in scrap metal and rabbit skins.

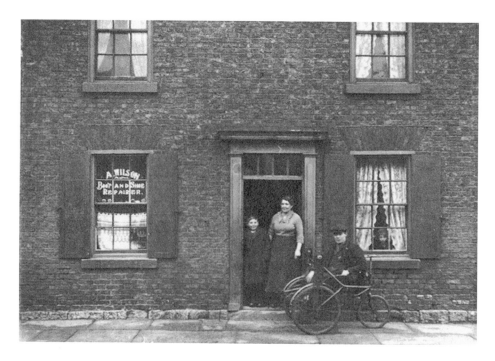

Wilson's the Cobblers York Road 1928

An intriguing shot of this cobblers and a good example of a business being run from home. Tadcaster was one of England's first post towns – where horses were changed in a kind of relay between major towns, in this case the road between London and Edinburgh via York. In the mid 1600s the Post Master was a Mr Taylor, landlord of the Swanne Inn. The journey to London took four days and cost 40s (£2). In 1880 fifty stage coaches passed through Tadcaster with thirty or so stopping to change horses.

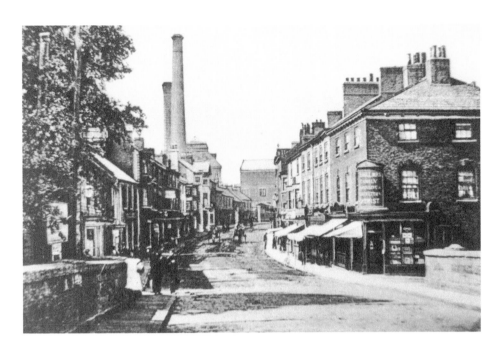

Hull Chemist's in Bridge Street

About 1904; J. H. Hull the chemist's and photographic dealer is the building with the curved corner on the left with shops beyond with their sun canopies covering the pavement. Again, John Smith's dominates the background. A contemporary advert gives Hull's mission statement: *"Buy your drugs and chemicals from J. H. Hull...because he believes that GOOD DRUGS give good results; good results give a good reputation, and a good reputation brings lots of customers."* Physicians' prescriptions, toilet preparations and requisites, aerated and mineral waters and patent medicines were all on offer as well as cameras, film, plates and a dark room. Today the street is still a busy shopping area.

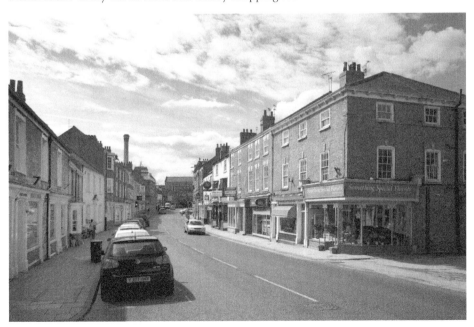

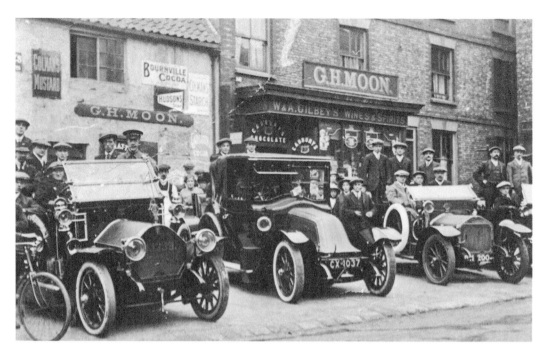

G. H. Moon

A 1914 shot of the Market Place with a splendid display of motor cars – the one in the middle is the John Smith's Brewery car with the chauffeur, Harry Linfoot, on its right. Next door to Moon's was Miss Couch's tearooms and confectioners providing *"excellent temperance refreshments for cyclists"* according to an advertisement of the time. Moon's also sold garden equipment. The new picture shows how much has changed, not least the cars.

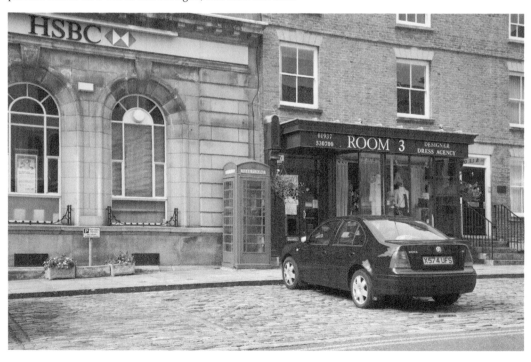

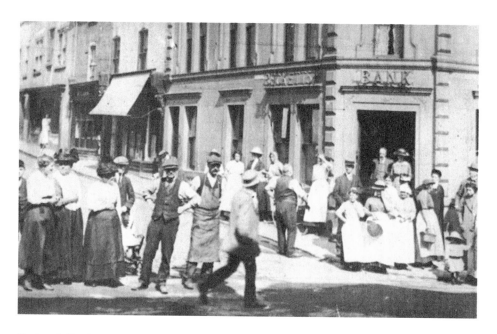

Beckett's Bank

An early 1900s shot of workers, domestic staff and shoppers outside Beckett's Bank at the bottom of Kirkgate. The bank had moved in to the premises formerly occupied by the Co-op which moved to the top of Chapel Street. Beckett's was founded around 1750 in Leeds and at its peak had thirty-seven branches. The bank eventually became the Wakefield & Barnsley, and then Barclays. Beckett's survives to this day as a pub in Park Row, Leeds – in an old Beckett's Bank building. A different bank today occupies the site.

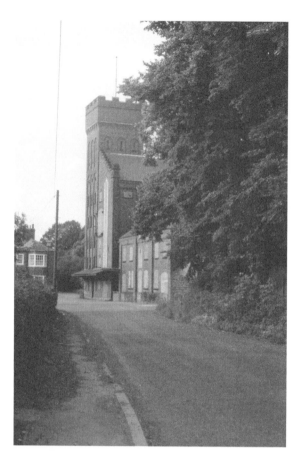

Mill House, Mill Lane
This imposing building at the end of Mill Lane had a number of incarnations; it started life as Ingleby's flour mill; more recently it was a John Smith's bonded warehouse for many years with beers and spirits coming and going under the scrutiny of HM Customs. It was demolished in 1982.

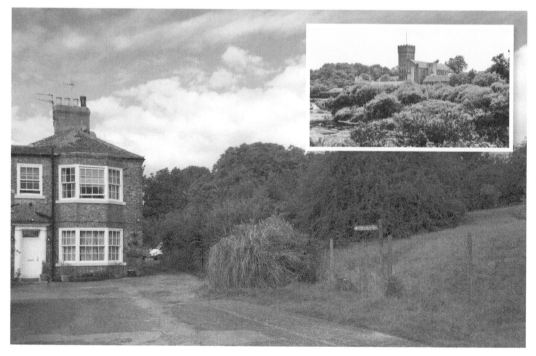

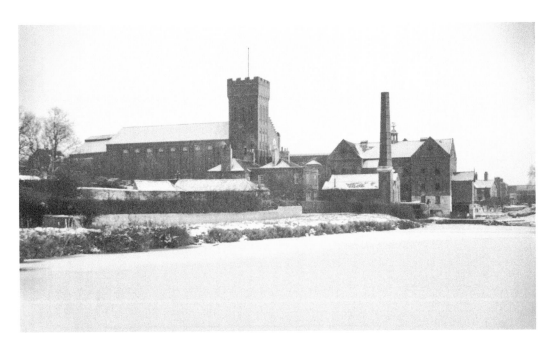

Ingleby's Flour Mill

Taken around 1910 the mill at this time had been converted in 1901 to become the town's first electricity generating station. The diesel generator fell through the floor due to its weight. Tadcaster Electricity Company's tariff offered units at 6d with three free light fittings. Coal was brought by rail across the viaduct – thus providing a use for it when the Leeds to York line project was abandoned. It became known as the Ingleby Mills Branch and closed in 1959. The new picture shows what a pleasant riverside the area now is.

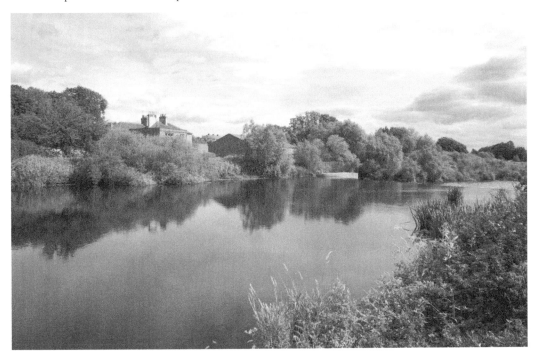

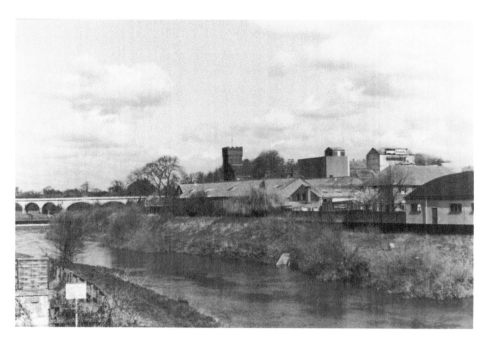

Page's Mills

Now demolished with a Sainsbury's now nearby. Part of this was built in 1844 by the Allenbys. Dixon's Field was near here, the site of the town's fair. The original mill on the site to the right of the viaduct was a soke mill owned by the Lord of the Manor and leased to the Allenbys in 1798. The Allenbys ran the mill through four generations until 1852 when John Allenby was killed when thrown from his horse returning from York market. The Rishworth family took over for a short time, followed by the Inglebys. They built the new mill in the old picture here with its striking tower.

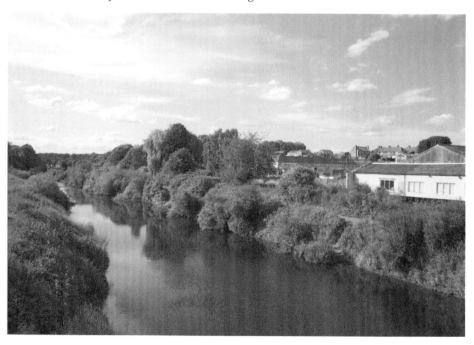

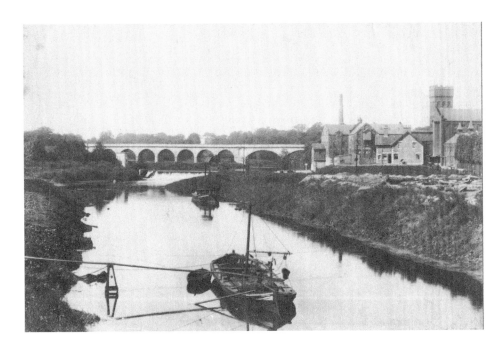

Sam Hodgson's Coal Barge 1920

The river was of course for many years a veritable hive of industry. Apart from coal transportation in what is probably Sam Hodgson's coal barge at the Coal Yard wharf at the bottom of Hodgson's Terrace – pictured here – sand was an important commodity too. It was dredged from the River Wharfe in the late nineteenth and early twentieth centuries and sold to local industries and business; Brayshaw's builders were the main players in this business; the warehouse was in Hodgson's Terrace. Sam Hodgson and William Dawson of the Britannia were the two businessmen running barges on the river up to around 1914. The Fish House is the building to the left of the weir.

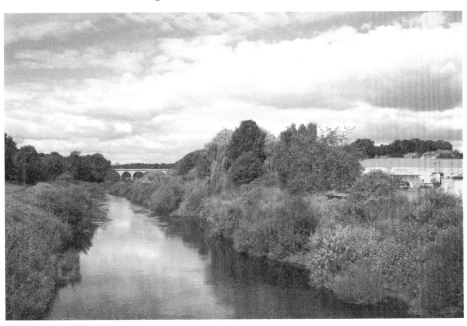

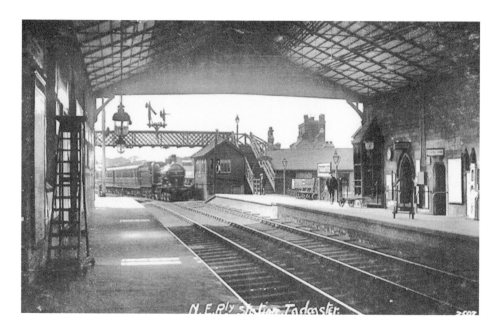

Tadcaster Station about 1915

On the line between Church Fenton and Harrogate which opened in 1847 and was owned by the York & North Midland Railway Company and designed by G. T. Andrews, the architect responsible for the elegant de Grey Rooms and the Bar Convent façade in York. The goods yards and station occupied over eight acres between Station Rd and Leeds Rd. In 1854 it was staffed by a station master, eight labourers and two porters. In 1911 30,000 tickets were sold and there were nine trains in each direction by 1932. During the war the line served the munitions factory at Thorp Arch. The station closed to passenger traffic in 1964 and was demolished (despite its designation as a listed building) later to make room for the Station Industrial Estate. The lorry is a reminder of how much transport now goes by road rather than rail.

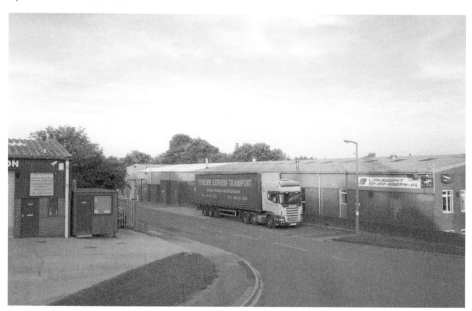

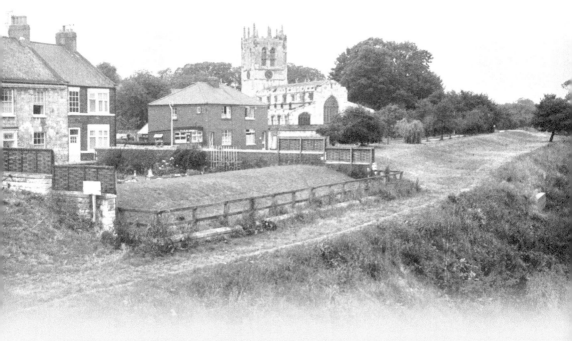

CHAPTER 4

School & Church

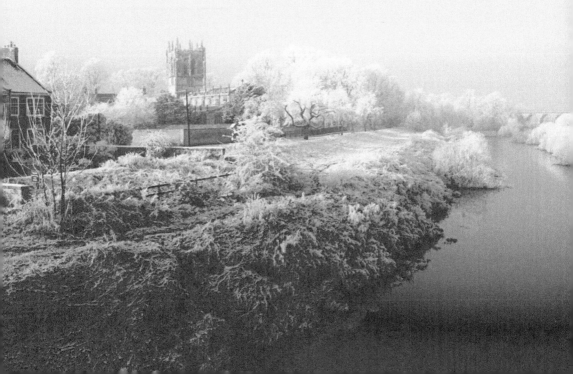

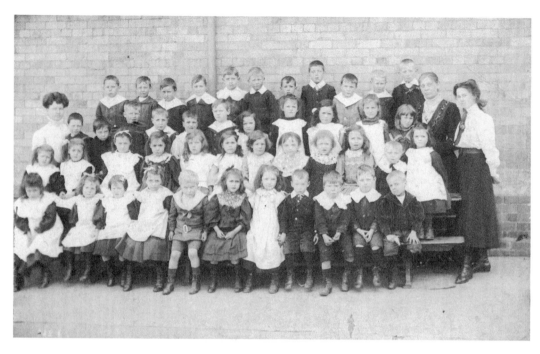

Tadcaster Board School 1921 and St Joseph's Pre-School 2010
School photograph time for pupils at the Board School in Station Road. The school was built and opened in 1877 and survived until 1984 when it transferred to Riverside Primary School in Wetherby Road. Teachers Misses Deighton and Holgreaves can be seen at either end of the second row from the back. Miss Kettlewell, the headmistress is on Miss Holgreaves' right. A not altogether joyous occasion it seems in 1921 – unlike today's experience, if the happy, smiling faces at the lively pre-School playgroup are anything to go by.

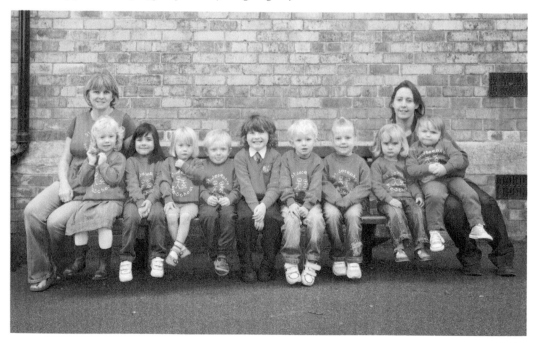

54

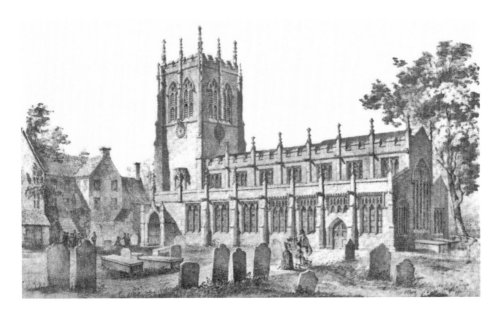

Oglethorpe School about 1850

The original school (on the left) was founded by Owen Oglethorpe who was born in 1503 and went on to become Vice Chancellor of Oxford University and Bishop of Carlisle; he also officiated at the coronation of Queen Elizabeth I. He established the 'School and Hospital or Almhouse of Jesus Christ of Tadcaster' in 1557. Hours were 6 am to 11 am and 1pm to 5 pm with an afternoon each week *"free for honest exercise and recreation."* The almhouse was for twelve poor people. A new school pictured here to the left of the church was built in the 1760s – the Old Grammar School. In 1865 an inspection showed it to have sixty boys and to be failing badly: the headmaster, the Revd W. C. Bellhouse, charged no fees, taught no Latin and set no homework; it was in effect apparently no better than a primary school. In 1878 it revived as Oglethorpe Endowed School. Today the buildings are in use as, on the left, a church hall and, to the right, private flats.

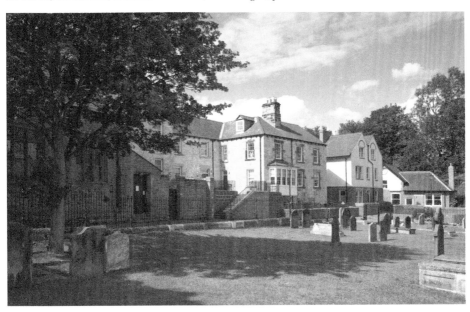

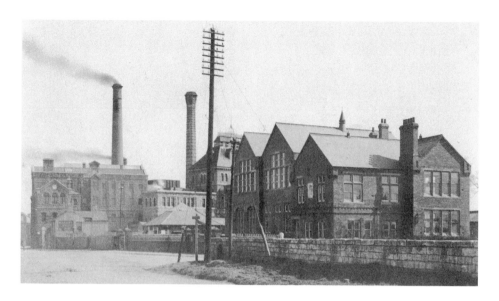

Tadcaster Grammar School

Taken around 1915 this shows the Grammar School on the corner of Leeds Road (formerly Lady Pitts) and London Road. The John Smith's chimneys can be seen in the background with the cattle market in between. Previously the building was occupied by Henrietta Dawson's Girls' School founded in 1888 and offering girls Domestic Economy, Laws of Health, Drill and Geometry as well as the usual subjects. In 1906 Oglethorpe merged with Dawson and became known as Tadcaster Grammar School. An inspection in 1909 was highly critical with one of its recommendations being that *"the wall between the boys' playground and the cattle market should be raised because it is not high enough to prevent unseemly interruptions."* The modern photographs (clockwise) the old Leeds Road site as it is today, the new Independent Learning Centre, the new Science building and reunion attendees outside the Great Hall in 2010.

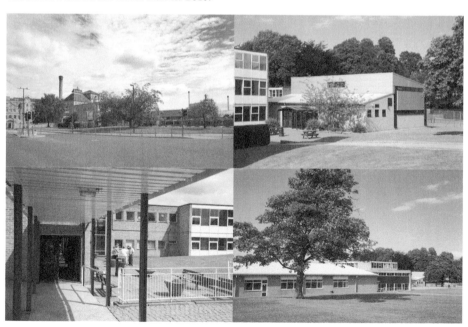

Tadcaster Grammar School VIth Formers 1979

In 1951 the Grammar School moved to its present site at Toulston Lodge, an Elizabethan house once apparently belonging to Oliver Cromwell; the striking wooden elephant heads, marble fireplace and bow windows in the hall are late Victorian. The modern photograph shows visitors at the 2010 reunion looking at the exhibition celebrating the fiftieth anniversary of the Toulston site in the new Independent Leaning Centre. Early visitors to the hall included George IV and Wellington; it saw service as a boarding school in the nineteenth century. The Riley-Smiths of John Smith brewery fame owned the house from around 1886 for a number of years.

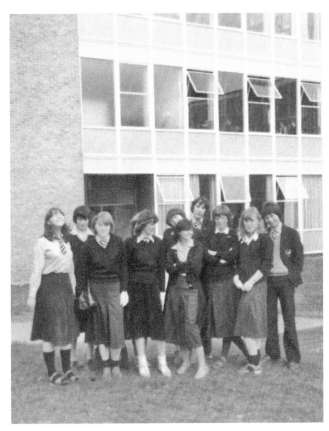

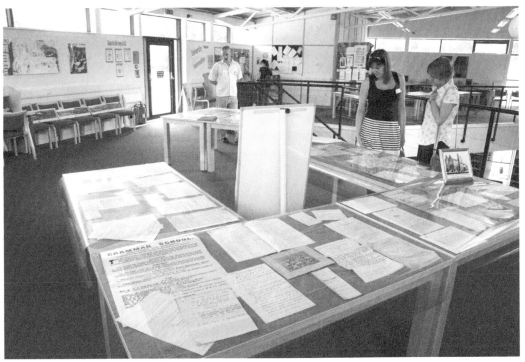

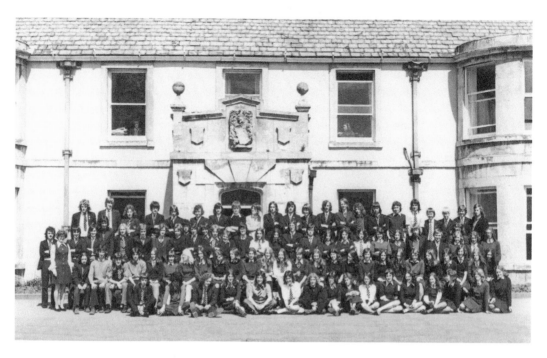

Toulston Lodge Group Shot

The boys' hairstyles give the older photograph away as sometime around the mid '70s. The move in 1951 only involved the senior school with the lower school remaining at Leeds Road until 1959 with staff commuting between the two sites by taxi! New buildings including a science block and boys' gym went up during the '50s so that 1,200 pupils could be accommodated. The dedicated school train survived until 1959 bringing students in from Wetherby and Collingham – one of the lesser known Beeching style cuts.

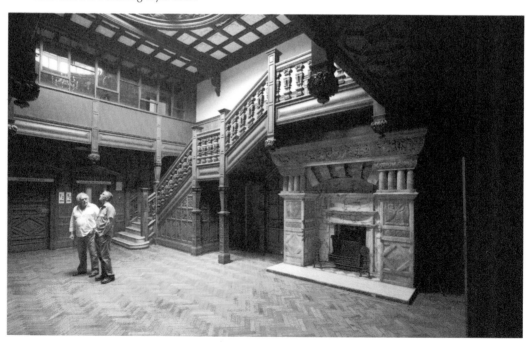

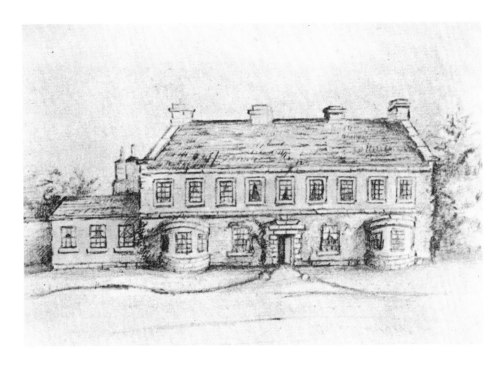

Toulston Lodge 1828

The head from 1944-1972 was Mr W. N. Bicknell, who got the job out of 268 applicants. He inherited a school role of 331 students rising to as many as 1,800 under his headship. Destinations during his time were impressive with students gaining places in thirty-five different universities and forty-four colleges of education including twenty-five at Oxford or Cambridge with two winning Blues in sport. Among his more celebrated events were the legendary Christmas parties and two Shakespeare trips to Stratford involving the whole school and chartered trains from Tadcaster.

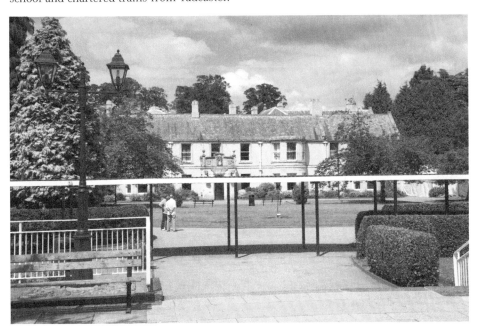

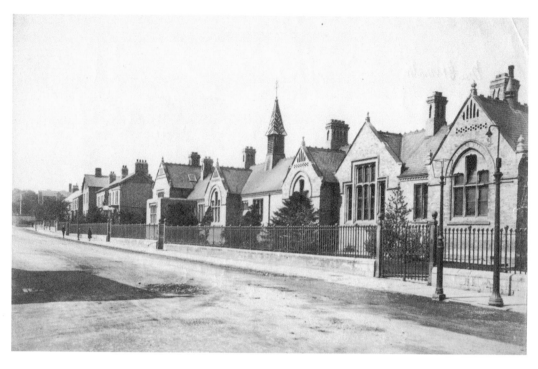

Tadcaster Board School

After the 1870 Education Act the Tadcaster school board was set up in 1875 and the school completed and opened in January 1878. The site is now shared by Tadcaster library and St Joseph's R. C. Primary School.

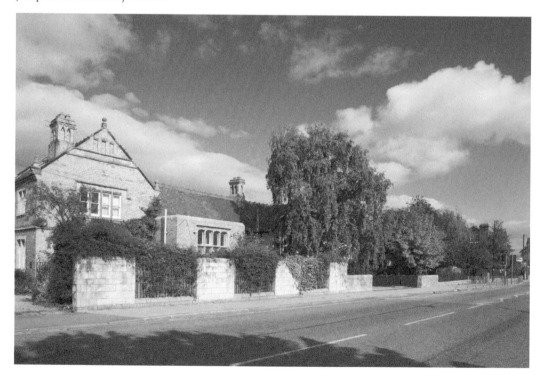

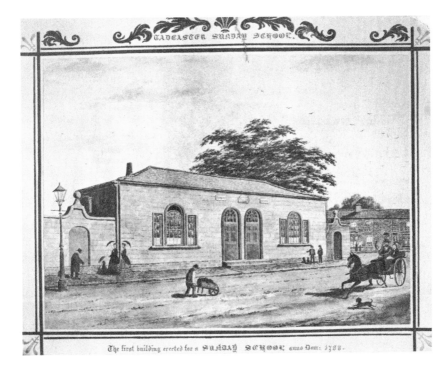

The first building erected for a SUNDAY SCHOOL anno Dom: 1788.

Sunday School

The Sunday School here in Westgate opposite the Calcaria pub around 1900 is possibly the oldest such building in England having been built in 1788 and paid for by public subscription. *The York Courant* reported: *The Sunday Schools at Tadcaster met with incredible success, where very many of both sexes attend the Church and the School to learn their duty to God and Man, who before lived in gross neglect or open profanation of the Lord's Day – it is to be wished that other towns and villages would follow this laudable example.* The building was also used for a time by the Dawson School. Today it is occupied by Selby College Learning Centre.

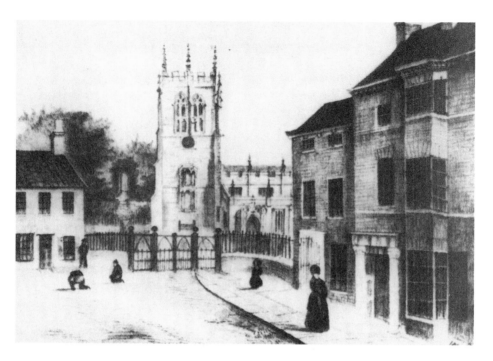

St Mary's

From a drawing by John Spence. Originally the church was surrounded by six feet high railings which were removed during the war. The original stone church here was built in 1150 to replace an earlier wooden building; it was destroyed by marauding Scots in 1318 after the Battle of Bannockburn and rebuilt between 1380 and 1480. The church in the picture dates from the fifteenth century. The church railings have had a chequered history being removed and then restored in the time between the two pictures.

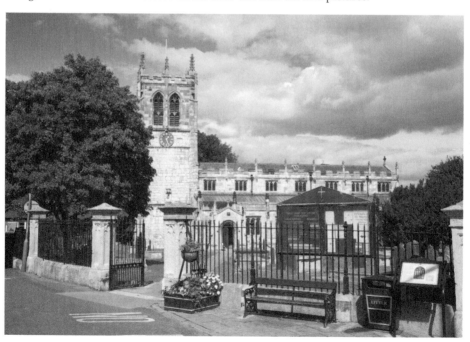

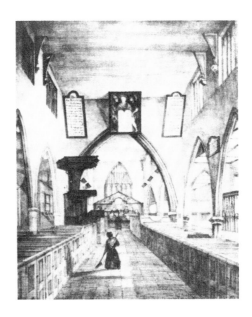

St Mary's and William Morris

Flooding was always a problem so between 1875 and 1877 the church was dismantled brick by brick and rebuilt on foundations five feet higher. The tower wasn't raised but the floor in the baptistery was instead. The money required, £8,426 4s 6½d, was raised by public subscription. A contemporary petition read: *"The river frequently breaks unto the church, and makes such depth of water that the petitioners cannot assemble to Divine service therein without imminent danger to their lives."* It was at this time that the famous William Morris stained glass east window was added (on the right): Morris was responsible for the top tier, Burne-Jones the rest. Pre-Raphaelite Morris put a different emphasis on Christianity, influenced as he was by his Christian Socialist vision of heaven on earth: he and the Arts and Crafts movement believed that peace, healing, justice and plenty could be achieved in this life and this realism is reflected in his images in the window. The three ages of womenhood window (on the right of the new photograph) showing spinsterhood, motherhood and widowhood, as in *Proverbs* 31, was made in 1879. The old image is from a drawing by John Spence.

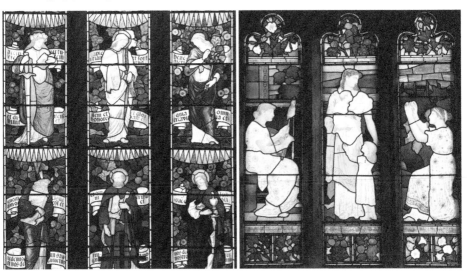

The Old Vicarage

Records indicating a vicarage here date back to 1290; the building here is fifteenth century which makes it about as old as the Ark, as it were (see page 84). It was a vicarage until 1829 when the then vicar, the Revd Benjamin Maddock moved into Edgerton Lodge on Station Road. It then became a girls' boarding school run by Misses Catherine and Mary Tasker and then a boys' school until 1850 when they transferred to Toulston Lodge. It became a vicarage again in 1890 until the 1930s. After that it was the HQ of the Tadcaster British Legion until 1987. It has been empty ever since, fine building though it is.

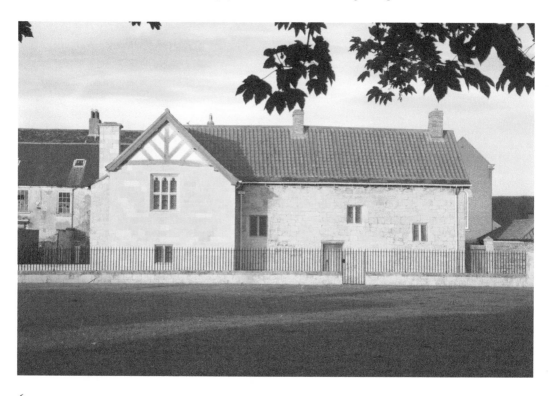

CHAPTER 5

Tadcaster People
& Events

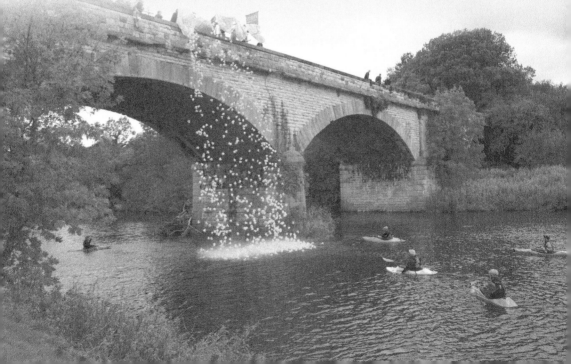

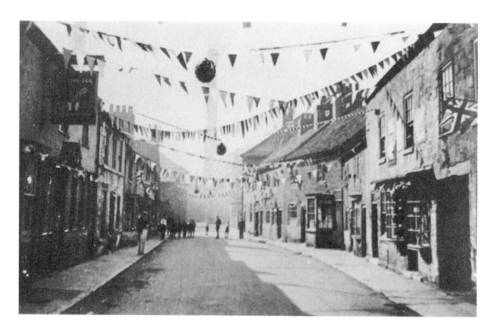

Chapel Street Silver Jubilee

Festivities for George V's Silver Jubilee in 1935 with the breweries in the background. The shop on the right with the bow window was a grocer's run by Nellie Richardson; the Falcon is on the left. The Methodist chapel opened near here in 1828 in Malt Kiln Square between Chapel Street and Kirkgate and cost £3000; it was a boys' Sunday School in the 1920s and a brass band practice room and ballroom before it was demolished in the '60s to make way for a car park. Strafford House is opposite.

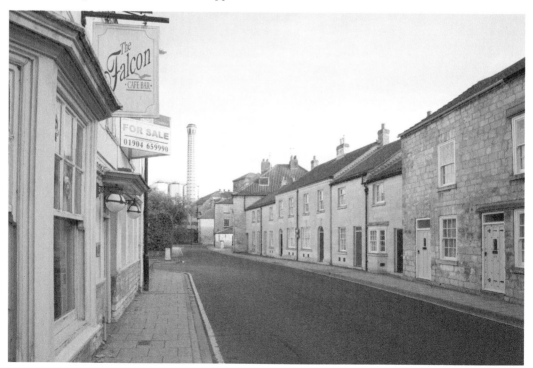

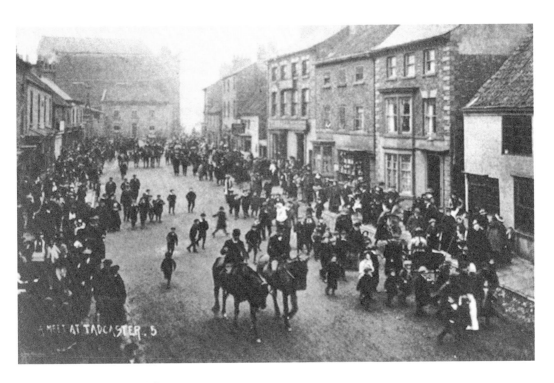

Hunt Meeting in High Street
A meet of the Bramham Hunt around 1912.

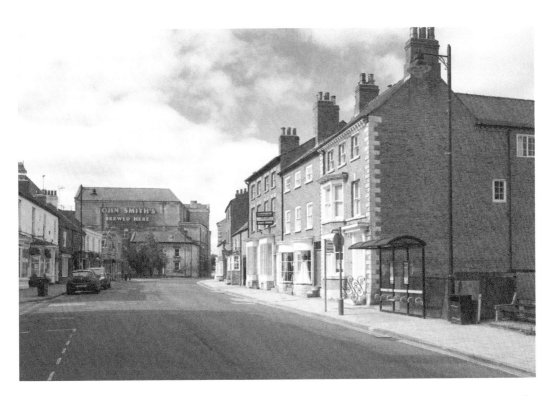

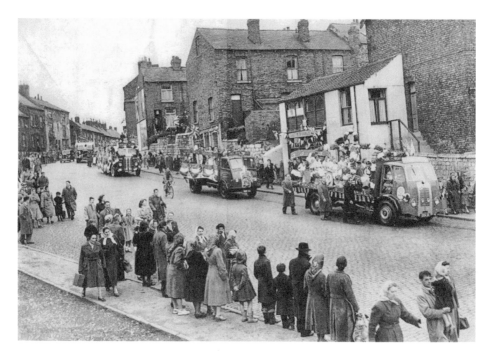

Commercial Street Coronation Celebrations

Celebrations in Commercial Street for Queen Elizabeth's coronation in 1953. What was later to become Garth Antiques is the white building on the right. Tadcaster's nearby market place goes back to 1270 when Henry de Percy obtained a royal charter from Henry III to hold 'a market and fair at his manor of Tadcaster', every Tuesday. This ancient market place was at the present day junction of Kirkgate and Bridge Street. A stone base which was part of the original market cross used to stand on Westgate where the Tadcaster War Memorial is now. Today's market is held on Thursdays in the car park of Tadcaster Social Club on St. Joseph's Street

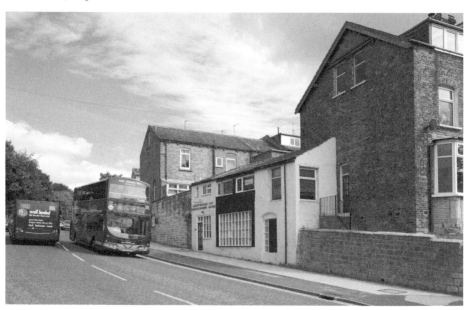

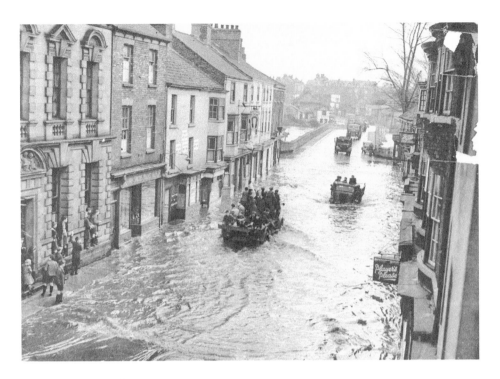

Bridge Street Floods 1950

Bridge Street flooded quite frequently. Here we can see improvised means of transport sailing down the street. Celia Fiennes in 1697 describes Tadcaster and her flooding in the late seventeenth century: *"This stands on a very large River Called the Whart. Just before you Come to ye town there is some of ye water wch on Great raines are not to be pass'd – it was very deep when I went through."* The inset shows delighted schoolchildren being taken to school by horse in 1935.

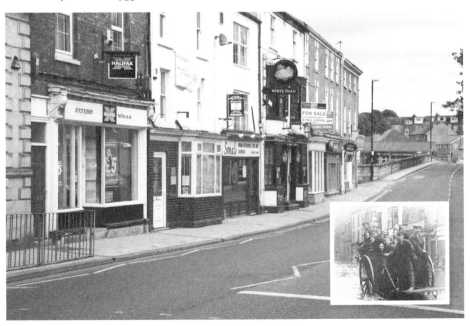

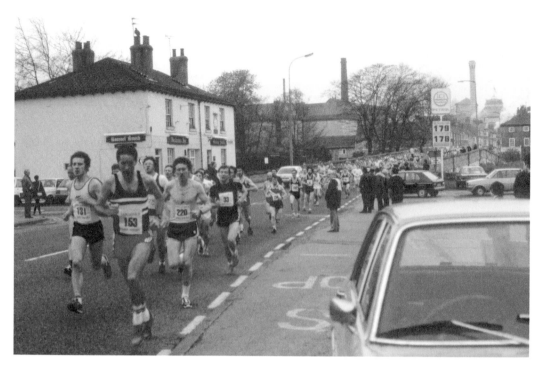

Tadcaster 10k 1983

The old image shows the Tadcaster 10k road race in 1983 with the Britannia Inn on the left. Tadcaster Harriers Running Club was re-formed in that year. The race had been organised by Tadcaster Methodist Church as a fundraiser for their rebuilding project. The Tadcaster 10k became an annual event and the race organisation was then taken over by the newly formed Tadcaster Harriers. The road race is now defunct, but the Harriers are still going strong and still do a track 10k at Tadcaster Grammar School in July every year.

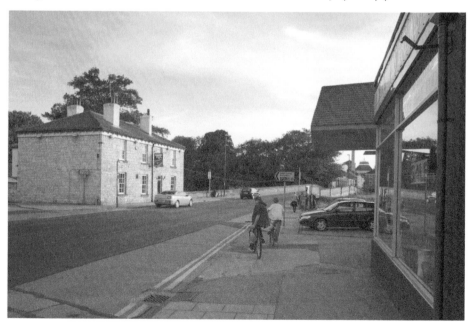

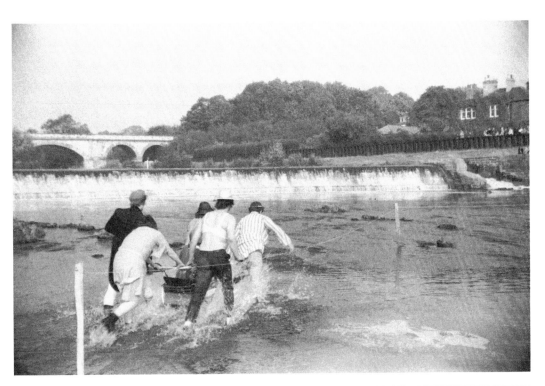

Tadcaster Pram Race
Crossing the Wharfe in a 1970s pram race organised by local pubs; the contestants then seem quite unconcerned about the steep drop which manifests itself in the modern picture.

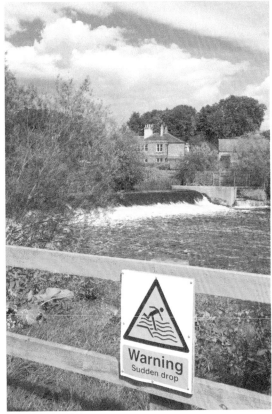

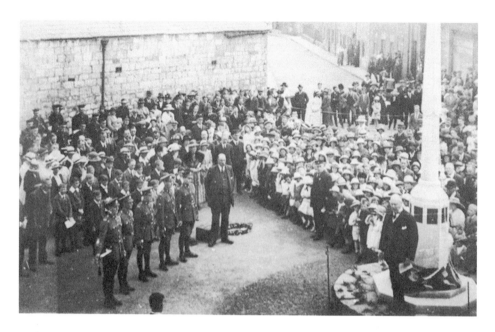

Tadcaster War Memorial 1921

The commemorative service for the new war memorial built in 1921 on the site of the old market cross. Westgate is in the background. The memorial remembers twenty-six fallen in the First World War and twenty-five in the Second World War; those fallen in the first war lost their lives in the following theatres: Passchendaele, Gallipoli, Persia, India, Mons, Somme, Ypres, Alexandria. The modern photograph is courtesy of Ian Glover.

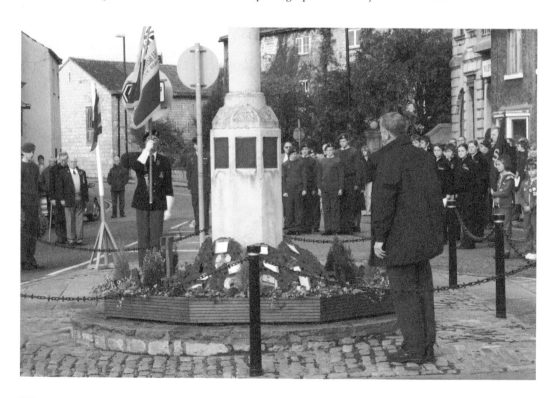

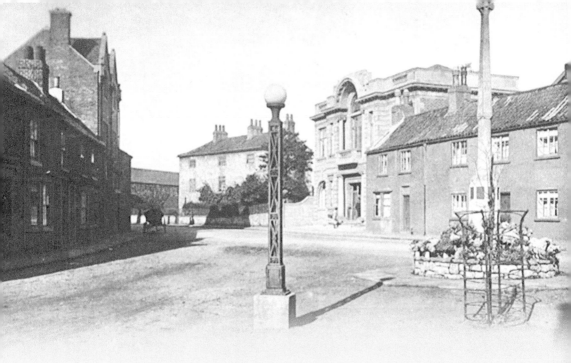

CHAPTER 6

A Tour Around
Tadcaster

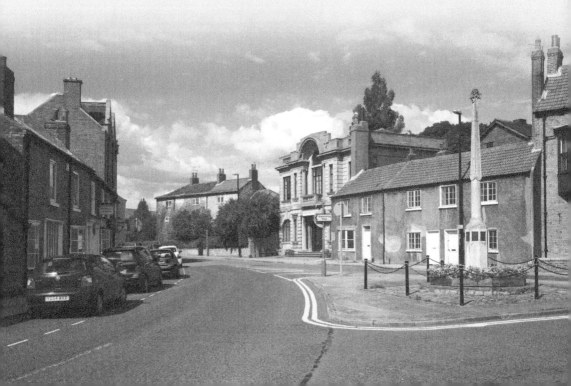

Wighill Lane 1970

The site of another of Tadcaster's industries was off Wighill Lane: Crane Wharf was where Cameron's the brick and tile makers had their factory. The warehouse and cottage have long gone, replaced by a house built from the bricks from the warehouse. The fence and the chimney pots are also from the old cottage. Crane Wharf gets its name from the crane once situated here. The boats moored here were owned by the Dysons who lived in the Britannia Inn and named one of their boats after the inn. Modern housing now replaces the industrial units.

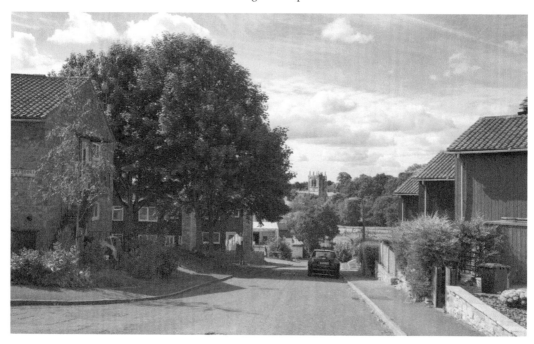

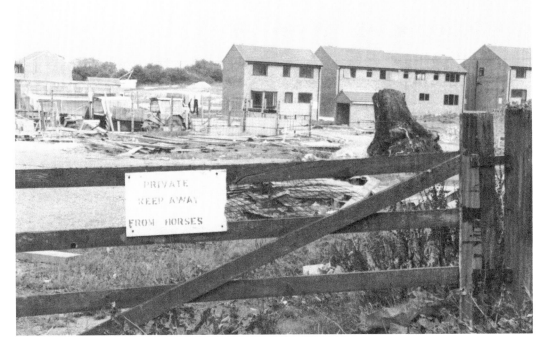

Parkland Drive

The horses probably had nothing much to do with the half built condition of the houses at the back of Mayfield Terrace seeing as they were completed to form the Parkland Drive Estate – the photographs are looking towards Parkland drive from Meadow Way.

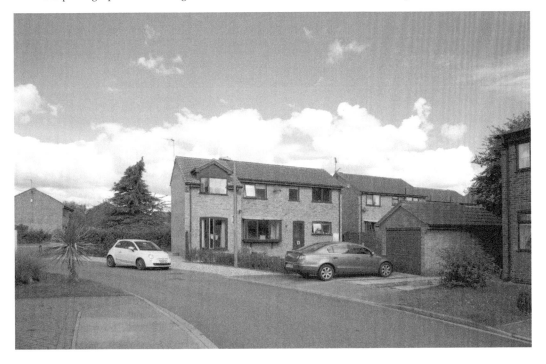

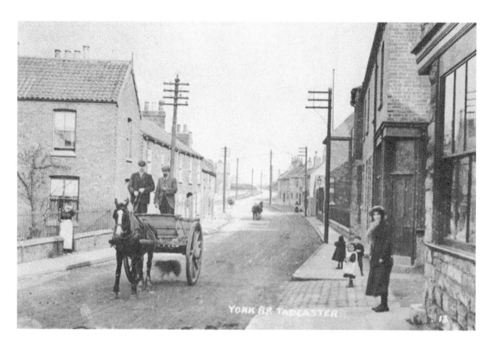

York Road c. 1905
York Road in 1913 looking towards York. The Travelling Man pub is on the right with
Parkland Drive further up. The inset stand pipe was situated in York Road.

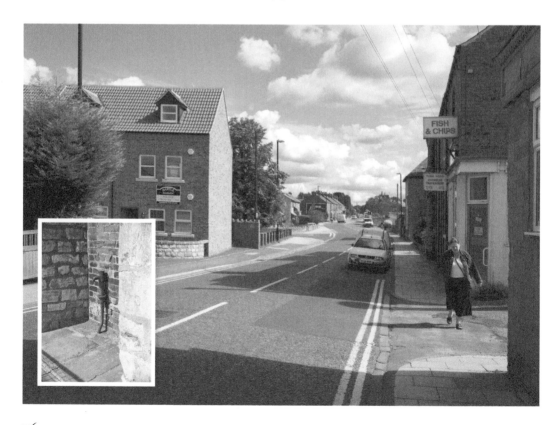

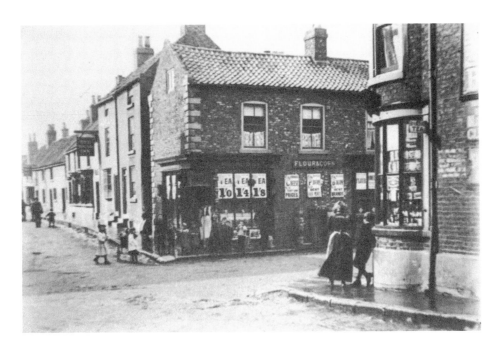

Wighill Lane

The junction of Wighill Lane and York Road with Holliday's grocer's – Flour & Corn Suppliers, in the centre and Harrison's grocer's and sweet shop on the right. Harrison's was formerly the Elephant and Castle. Next door to Holliday's is The Royal Oak and next door to that The Boot and Shoe Inn which was one of the few pubs owned by John Smith in 1892 at its incorporation as a limited company and run by Timothy Rooke, a coal merchant, horse and motor hire company and haulier.

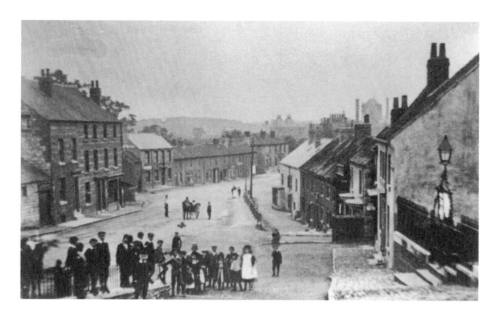

Commercial Street 1907

A group of children gathered here on Commercial Street with The Britannia owned by John and William Dyson and The Coach and Horses (originally The Half Moon and promoting *"Good Stabling"*) pubs on the left. A 1901 advert shows us that it was keen to attract the emerging cyclists' market, calling itself the *"Cyclists House – Dinners, Teas and Refreshments provided for Cyclists and Parties.* " Dyson's brother William lived over the bridge at No 1 Bridge St; he left money in his will to pay for the Salvation Army citadel in Chapel St which was known as Dyson's Tabernacle. William Dyson was also owner of river barges. The pub was named after their 90 ton keel boat which shipped the first ever cargo of John Smith beer to Hull for delivery to Amsterdam where it won a gold medal in 1895. Baron Londesborough sold The Britannia in 1873 to John Smith's for £900: *"Public House...stables, cowhouse and shed, cottage and warehouse, in occupation of Ann Dyson,"*

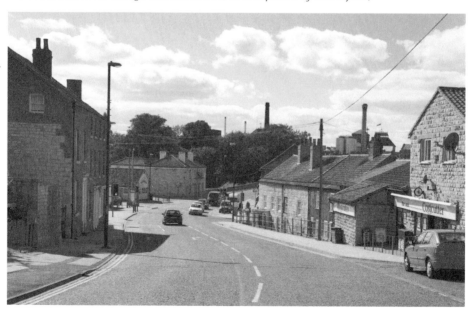

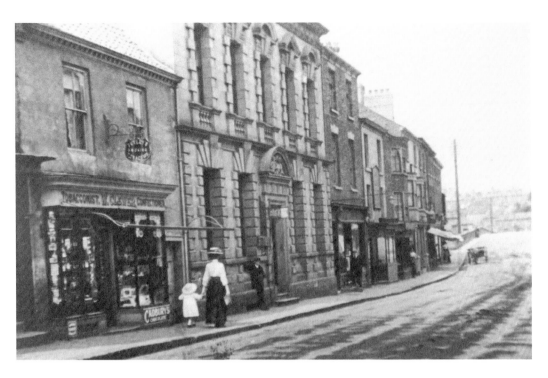

Bridge Street Spirit Store

The shop on the left is W. Clever, tobacconist and confectioner with Barclays Bank next to that. The next building, no 24, is John Smith's spirit store. Bought in 1924 it featured a hoist for deliveries to the three floors; the hoist, trap doors and winding gear are still in the building today.

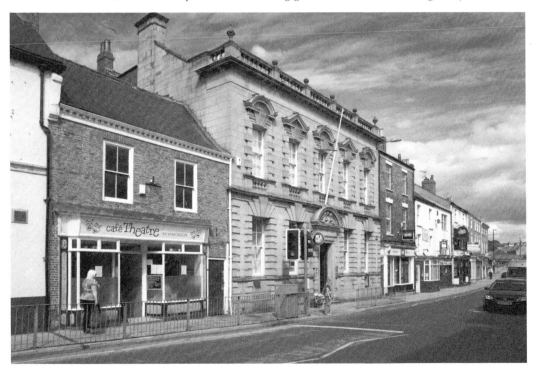

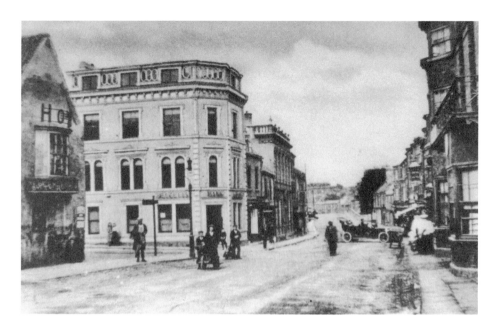

Bridge Street

What looks like an early attempt at a three point turn can be seen in the old photograph. The first building in Bridge Street used to be the Anchor, originally the Hope and Anchor, used by boatmen working on the river; the Golden Lion was nearby, now gone. The lion is the Lion of Flanders, emblematic of the fact that the hop was introduced to England from Belgium. The White Swan, however, has survived – at one time owned by a Joseph Middleton who lived through the reigns of six monarchs: George III, George IV, William IV, Victoria and Edward VII. He was born in 1815 just before the Battle of Waterloo and died in 1901. The green-tiled White Hart was nearby at No. 22. The Nat West bank is in the building once occupied by Beaumont's grocers and Beckett's Bank.

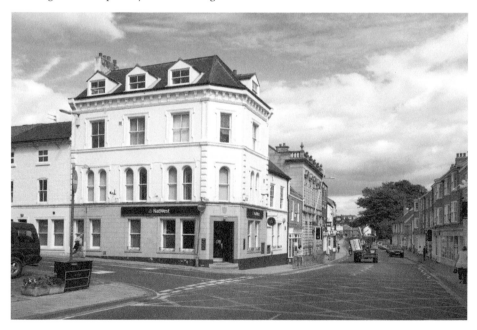

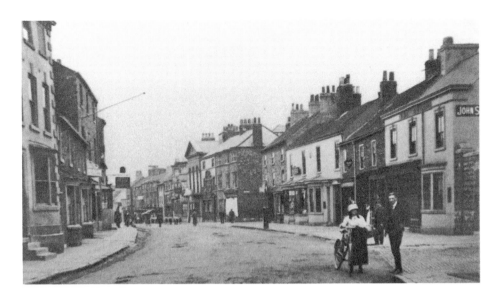

High Street Girl with a Bicycle

Taken around 1900 this shows Ye Olde Tea Room with The George and Dragon further down. The Queen pub is on the right closed and recently reopened; originally a dram shop, you can still see the name on the wall of the building. It was converted to The Queen Hotel in 1883 and was used as a social club by John Smith's from the 1980s. Strafford House faces back down the High Street – now part of John Smith's brewery. It is named after Thomas Wentworth Strafford – Black Tom – advisor to Charles I, President of the Council of the North and a governor of the grammar School. He was beheaded in 1641 after being impeached by Cromwell. Anna White owned it in 1700 and rebuilt it; it later became a school: first William Stacey's Academy and later Varley's Commercial School. New Street was once a residential street but is now occupied totally by breweries; the Malt Shovel used to be here. The Old Post Office was at No 11-15 High St, bearing the Lord Londesborough arms, as do all of his buildings; it was in use between 1870 and 1910 when it moved. At No 28 the Ministers of the Inghamite Church lived, including Benjamin Ingham himself.

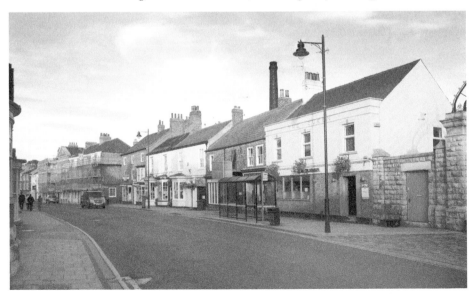

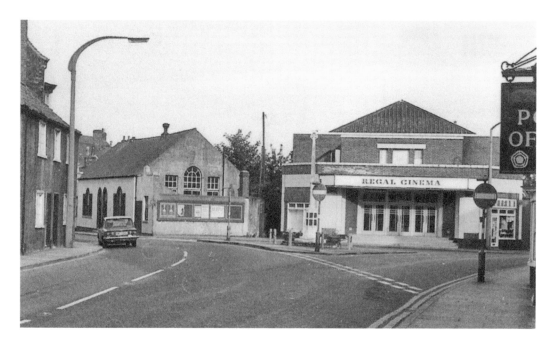

Regal Cinema and Cenotaph

The Regal opened in 1938 in Westgate and replaced the Cosy Cinema in the High Street. There was room for 670 cinema goers but still queues extending down Westgate into Kirkgate were a common sight. The premiere was *Maytime* starring Nelson Eddy and Jeanette Macdonald. Seats cost 1s 3d (about 6p), 1s 6d and 2s 6d (half a crown – 12 ½p); children's matinee on Saturday mornings cost 7d. The Regal closed in 1976 with a showing of *Where Eagles Dare*. It was demolished in 1986. The buildings in the modern shot are the Sunday School to the left and the Old Vicarage in the centre.

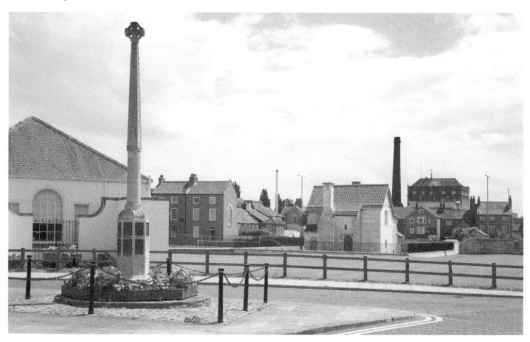

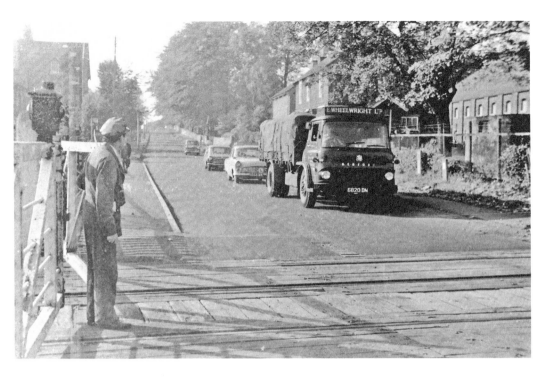

Station Road Level Crossing

A 1960s shot of the level crossing and the gatekeeper in Station Road. Originally there was a footbridge for pedestrians and goods yards. All this has now gone, as the modern photograph shows.

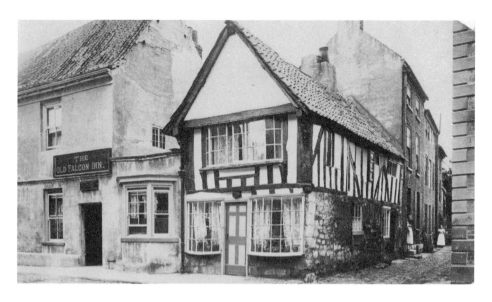

The Ark

Part of a much larger fifteenth-century building, what was Noah's Ark which got its name from the carved heads of Noah and Naamah his wife on corbels at the front of the building. In 1672 it was known as Morley Hall after Robert Morley who managed to get it licensed for Presbyterian meetings. It is reputedly where the Pilgrim Fathers met to plan their emigration to America; there is an exact copy of the Ark in Berlin Center, Ohio which is dedicated to providing a permanent safe haven for unwanted and abused exotic animals. In the nineteenth century this became a carpenter's shop until it was bought in 1959 by W. H. D. Riley-Smith and eventually became a museum until 1984, a museum again in 1985 to 1989 and offices of Tadcaster Town Council from 1992. To the left was the Old Falcon Inn run in 1844 by Thomas Liversedge a lime burner as well as publican – Tadcaster's last free house until bought by John Smith's in 1942.

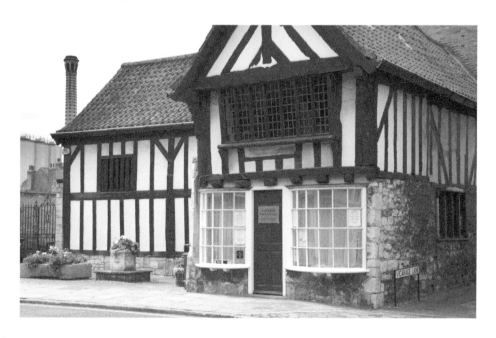

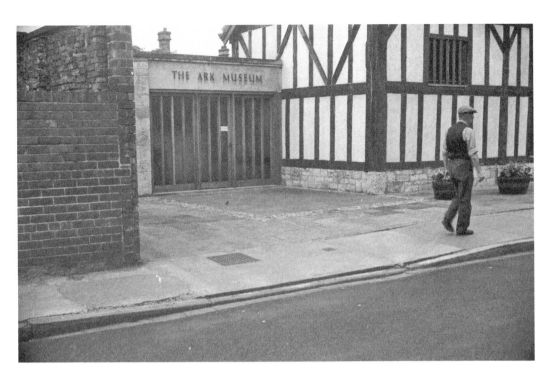

The Ark Museum
The block at right angles to the street is known as the solar after the solar range which was there. In the nineteenth century this became a carpenter's shop until it was bought in 1959 by W. H. D. Riley-Smith and eventually became a museum until 1984, a museum again in 1985 to 1989 and offices of Tadcaster Town Council from 1992.

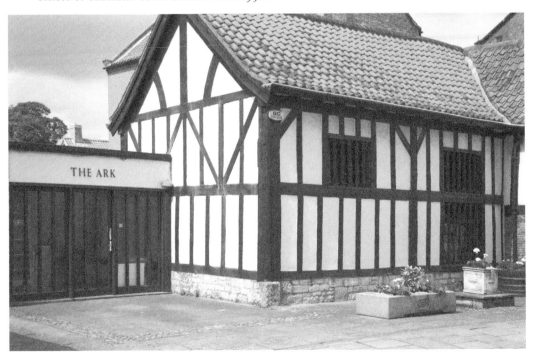

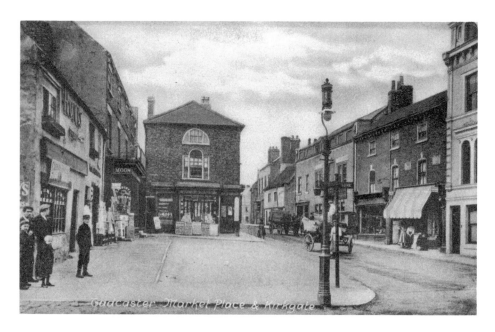

Market Place

Taken in 1908 this clearly shows C. Woodsons café and sweet shop on the left with the big *Hovis* and *Refreshments* signs, then G. H. Moon's grocer's; Askey's stationers, library and printers is directly opposite (later Grimston's). George Tindall's plumbers is on the right to the left of the shop with the awning and Barber's House Furnishers next to that in the building once occupied by the Railway Hotel. George Tindall was nothing if not versatile, offering his services as glazier, gas, water and steam fitter, bell hanger, plumber, sanitary and electric light engineer. Barber's later became Barber & Turner's – toy as well as a furniture shop. This is where Mr Rodgers of the Tower Brewery bought queues of boys and girls a present of their choice on Christmas Eve.

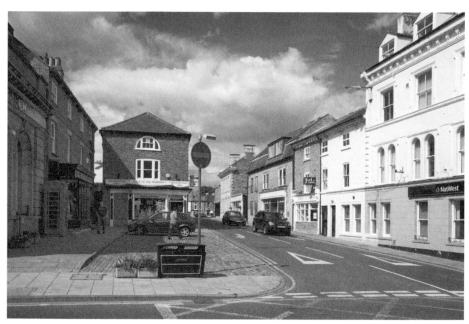

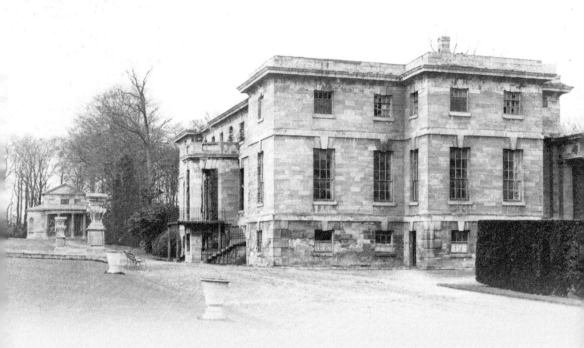

CHAPTER 7
Around About Tadcaster

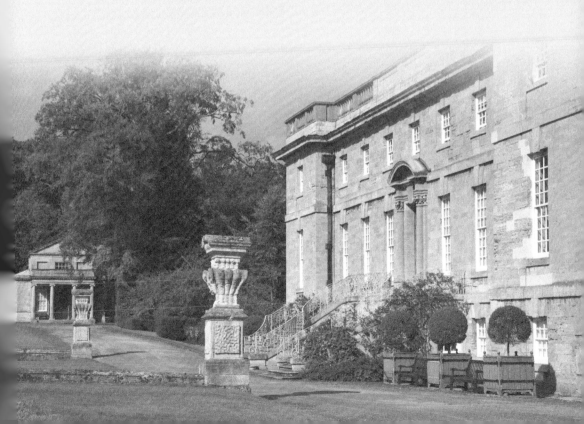

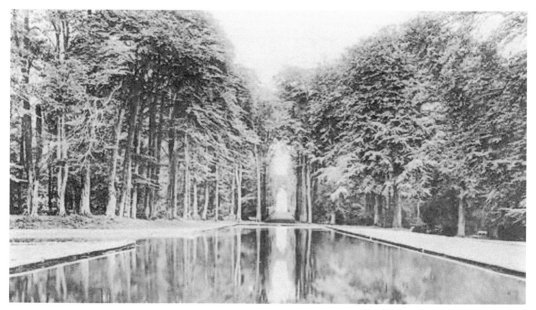

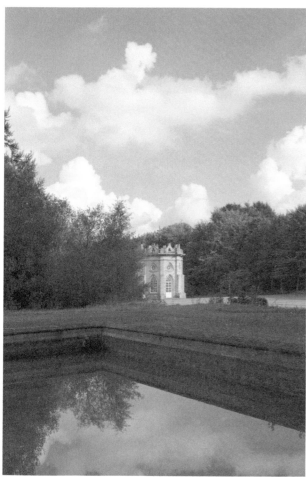

Bramham Park Grounds

This Baroque mansion was built in 1698 by Robert Benson, 1st Baron Bingley and has remained in the family ever since. It is situated in a landscaped park replete with follies and avenues in the eighteenth century landscape tradition. After a fire in 1828 the house remained derelict until its restoration in 1908. It remains a private residence today although you can visit by appointment and the 400 acre park is the venue for the annual Bramham Horse Trials and Leeds Festival. The Festival bill for 2010 included Arcade Fire, Blink 182, Guns n' Roses and Pete Docherty and the Libertines.

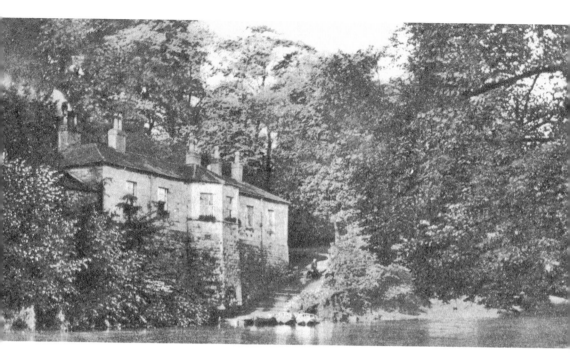

The Spa Baths, Boston Spa

In 1744, John Shires discovered magnesian, limestone and sulphur springs and so made Boston a spa town known then as Thorp Spaw but declined about the same time as Harrogate's fame was increasing.

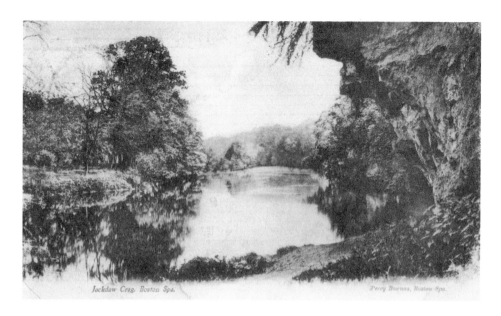

Jackdaw Crag, Boston Spa. Percy Bownas, Boston Spa.

Jackdaw Crag

Jackdaw Crag Quarries (some miles away near Stutton) is the main quarry for the much sought after Tadcaster limestone that was used in the construction of York and Beverley Minsters, Selby Abbey, York city walls, some of the colleges at Cambridge University and nearby Hazlewood catle. The quarry was in fact owned by the Vavasours of Hazlewood Castle and it was they who donated free stone to York Minster after the 1829 fire. The left hand figure above the Great West Door there is a Vavasour holding a piece of stone; the right hand figure is a de Perci carrying a piece of timber. The view here at the bottom of Deep Dale along the River Wharfe is very similar today and shows the carvings and colourful modern graffiti.

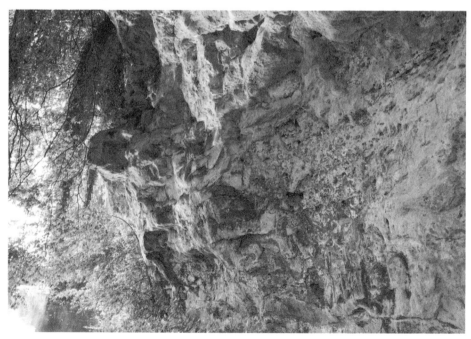

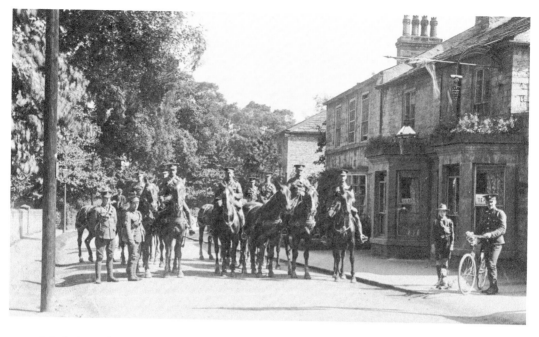

Admiral Hawke Hotel, Boston Spa

One of the many English pubs named after Edward Hawke, (1705 –1781) famous for his service during the Seven Years' War – particularly his victory over the French at the Battle of Quiberon Bay in 1759, preventing a French invasion of Britain. The story of Boston Spa started with The Royal Hotel built by Joseph Taite and originally called Farrers Hotel after the owner; it was built in 1753 and is the oldest recorded building. The first house was St. Kitts, in 1774; this was followed by Brook House in 1791 and Boston Hall in 1807. All have survived today although Boston Hall is now occupied as offices. The older photograph shows cavalrymen gathering outside the pub, which still survives today.

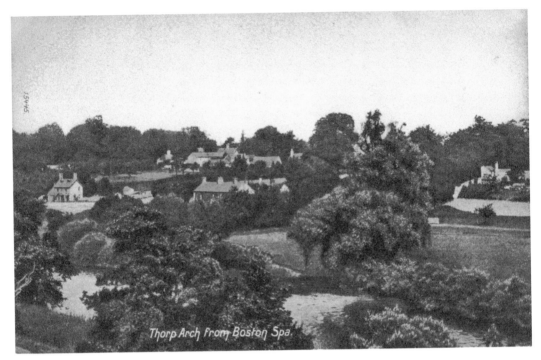

Thorp Arch from Boston Spa.

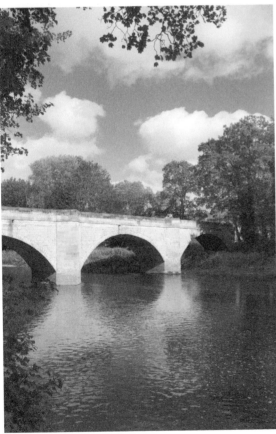

Thorp Arch from Boston Spa
During the Second World War
Thorp Arch was the home of a Royal
Ordnance Factory ammunition filling
factory. It produced light, medium and
heavy gun ammunition, land mines
and trench mortar ammunition for
the Army; medium and large bombs
for the RAF; and 20mm and other
small arms ammunition for all three
services. Some of these were produced
in millions and hundreds of millions
of units. It finally closed in 1958
after the Korean War. Part of the site
now houses the Northern Reading
Room, Northern Listening Service
and Document Supply Collection of
the British Library. Over 100km of
shelving is devoted to interlibrary
loans. The rest of the site is occupied
by Thorp Arch Trading Estate and two
prisons, now combined with Wealstun
Prison. Thorp Arch is mentioned
in the *Domesday* as a mill used by
brewers in Roman times.

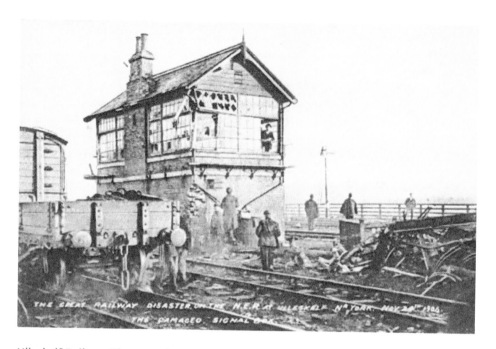

Ulleskelf Railway Disaster 26 May 1906

Four miles from Tadcaster the station opened in 1839 on the York and North Midland Railway. A more recent incident on 4 October 2010 involved a bovine incursion (cows on the line to you and me) when two out of the four cows were killed. Ulleskelf, derived from the Scandinavian, refers to Ulfr's shelf of land. In Domesday Ulleskelf was known as Oleschel and was part of the Archbishop of York's land. In 1066 at the Battle of Fulford Earl Edwin of Mercia moored his boats at Ulleskelf to prevent the invading army reaching York. An episode of *A Touch of Frost* was filmed in the village in 2008. Today's train rushes through without incident.

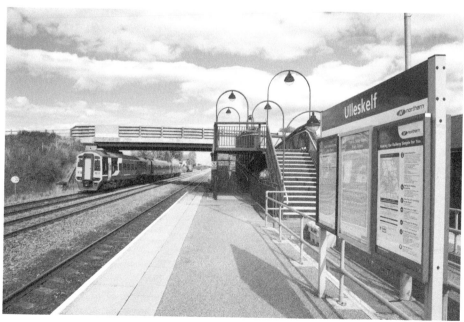

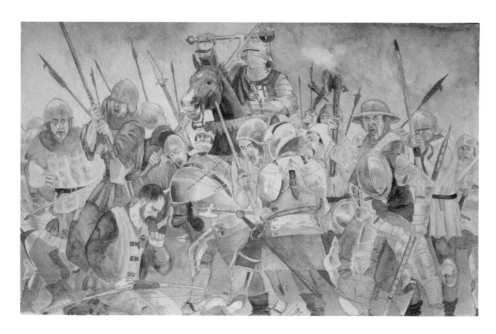

The Battle of Towton 29 March 1461 (Palm Sunday)

The Battle of Towton took place on 29 March 1461 between Towton and Saxton. It was a decisive victory for the Yorkists in the Wars of the Roses. Towton is the biggest battle ever fought in Britain: between 50,000 and 80,000 soldiers took part including twenty-eight lords – almost half the country's peerage. It was also the bloodiest battle ever fought in England with up to 28,000 casualties: roughly 1% of the population of England at the time. More probably died in the aftermath than in the battle itself because neither side gave quarter and nearby bridges collapsed under the weight of the armed men. The worst slaughter was at Bloody Meadow, where fugitives are said to have crossed the River Cock using the bodies of the fallen as a bridge. The graphic painting of the battle is by Paul Bishop. The splendid modern reenactments here and on page 95 are courtesy of the Towton Battlefield Society.

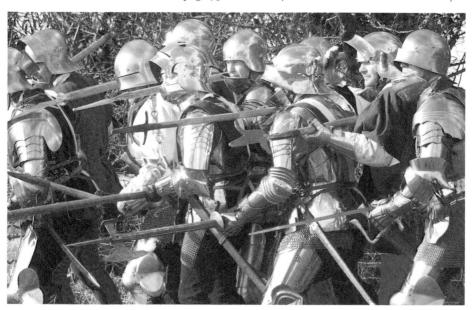

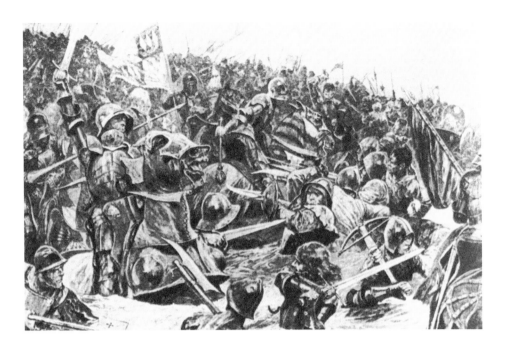

The Towton Mass Grave

In August 1996 workmen uncovered a portion of a mass grave during building work at the Towton battlefield. A team of osteoarchaeologists and archaeologists from Bradford University and the West Yorkshire Archaeology Service recovered the more or less complete remains of forty-three tightly packed casualties. Most had sustained multiple injuries from projectiles and hand-held weapons exceeding what is necessary to cause disability and death. The distribution of cuts and chops indicate that blows were largely concentrated in the craniofacial area, in some cases bisecting the face and cranial vault or detaching bone; in other cases the nose and ears had been sliced off. The injuries were apparently intended to sufficiently mutilate the bodies as to make them unidentifiable. The engraving is by R. Caton Woodville.

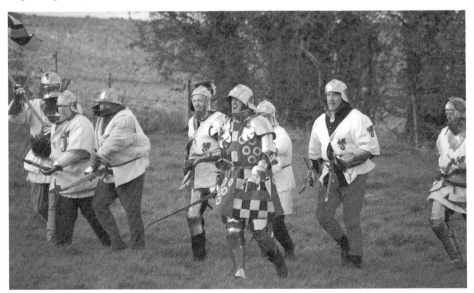

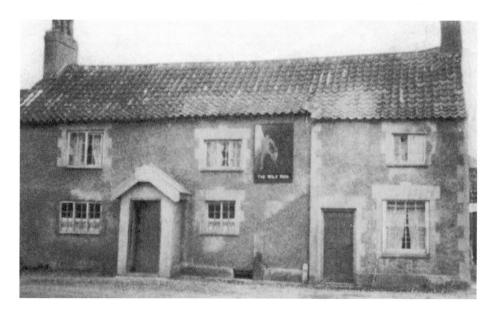

"A savage man all in ivy"

The Wild Man at Street Houses. Possibly originally called the Bush or something similar if the depositions of York Castle in 1675 are to be believed: Abraham Ibbotson of Leeds was charged with stealing horses, the felonious act being plotted at an ale house in Street Houses "in the way betwixt Tadcaster and York where there was a bush as a signe." The bush was associated with the Roman god Bacchus who was often depicted as a wild man on account of his characteristic state of frenzy and intoxication; the two symbols have become virtually synonymous. Legend has it that the almost life-size sign used to be covered up when Queen Victoria passed by en route to York with white calico "so that the Queen might not be shocked at the sight of so hairy (and naked) a man". Nowadays the Aaghra provides refreshment of a more exotic nature.